ORIANA

A PHOTOGRAPHIC JOURNEY

T0386650

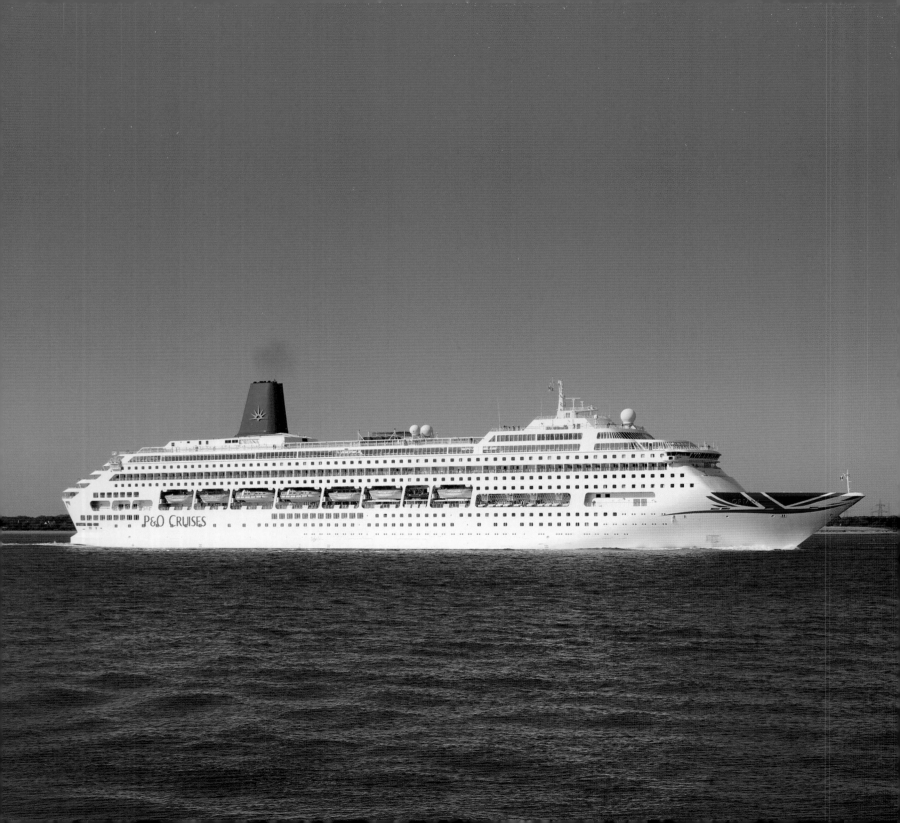

ORIANA

A PHOTOGRAPHIC JOURNEY

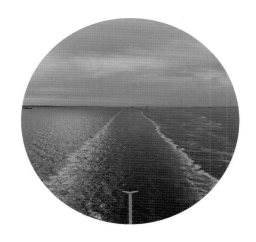

CHRIS FRAME AND RACHELLE CROSS

The History Press

For Zac and Callum

First published 2019

The History Press
The Mill
Brimscombe Port
Stroud
Gloucestershire
GL5 2QG
www.thehistorypress.co.uk

British Library Cataloguing in Publication Data.
A catalogue record for this book is available from the British Library.

ISBN 978 0 7509 8925 1
Typesetting and origination by The History Press
Printed and bound in India by Thomson Press India Ltd

CONTENTS ∽

ACKNOWLEDGEMENTS ⟡

While we were writing this book, P&O Cruises announced plans for *Oriana*'s retirement. As the ship completes her service career with P&O, we hope this book acts as a photographic memory of how she appeared towards the end of her career.

We want to thank everyone who helped us create this photographic journey of *Oriana*:

Special thanks to Commodore Ian Gibb and his wife Ann for their support in providing the Master's Perspective, as well as interesting facts and anecdotes throughout this book.

Bill Miller for providing the foreword. It has been a decade since Bill wrote the foreword for our first book, and the first in this series, *QE2: A Photographic Journey,* and his support over the past ten years has been greatly appreciated.

Andrew Sassoli-Walker for providing photographs of *Oriana*'s Bridge, as well as sharing information and answering questions whenever we asked.

Rob Henderson and Doug Cremer for providing imagery of the original *Oriana* and sharing their wealth of knowledge about P&O.

Patricia Dempsey for providing imagery of the *Oriana* in her original livery.

Andy and Ann-Marie Fitzsimmons, who helped us find the perfect location to photograph *Oriana* departing Southampton, and Andrew Skinner from SeaCity Museum for a tour of the Southampton Clock Tower, which offered a great view of the ship.

Jenny Hadley from P&O Cruises for supplying the 'Oriana Interesting Facts' information.

Amy Rigg from The History Press, who has been our partner in the creation of all of our books, as well as Megan Sheer, Glad Stockdale and Martin Latham for their design work and Jezz Palmer for helping us make this book a reality …

… and our families and friends for supporting us.

All photographs in this book were taken by Chris Frame and Rachelle Cross unless otherwise acknowledged.

FOREWORD ⟳ BY WILLIAM H. MILLER JR

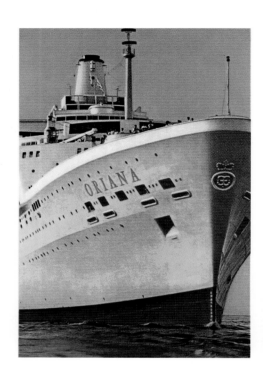

P&O is one of the greatest names in shipping. Their history is extensive, their fleet list lengthy. But, growing up in the 1950s along the banks of the Hudson River in New York Harbor, P&O was a distant name. Their ships seemed almost vague, and they plied far-off, often exotic routes. There were some later connections, however.

But in 1959, I well remember when the handsome near-sisters *Arcadia* and *Iberia* came to call. They were visiting on unusual transatlantic cruises. The ships remained at the Cunard piers for several days, and I purposely watched as both liners made early evening departures. Both seemed huge, even against the Manhattan skyline, and were impressively beautiful ships.

Above: The first *Oriana* entered service for P&O-Orient and was built for the Australian trade, cruising out of Sydney until she retired in 1986. (Henderson & Cremer)

Right: In her final P&O livery, *Oriana* sails from Southampton on 25 June 2018. Just a few days later P&O Cruises announced the ship's retirement.

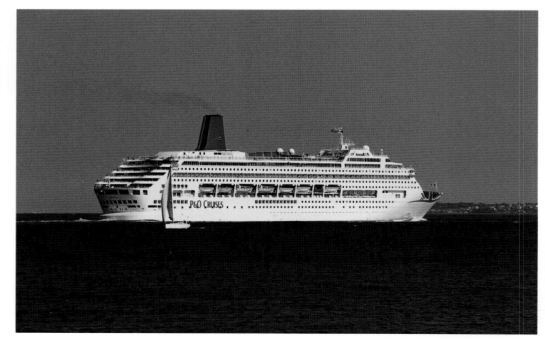

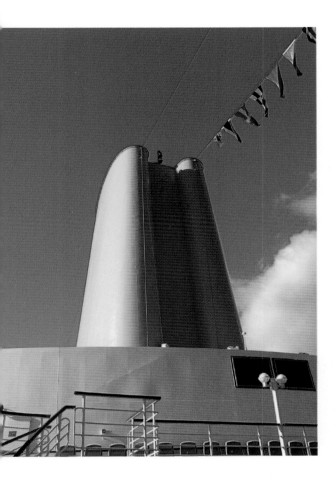

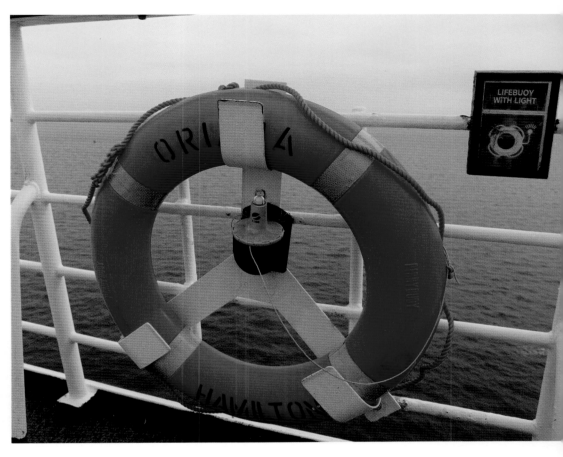

Then, in 1962, *Canberra* called for the first time. She was extraordinary: as she made her way up the Hudson, dressed in flags in bright, summery sunshine, she was every inch the stunning 'ship of tomorrow'. Few liners, I felt, had exteriors that hinted more of the future.

Thereafter, *Canberra* made regular visits to New York for many years. Then, in 1971, *Chusan* made her only call, visiting as part of a long cruise from faraway Cape Town. Happily, I was invited to lunch on board. She was pure P&O, pure British ocean liner: burl woods, lino floors, oversized chairs, floral print sofas and vast stretches of snow-white teak decking. Her charm included the smells on board, of Indian cooking, floor polish and soap.

Above left: The 1995-built *Oriana*'s funnel paid homage to the *Canberra*'s twin funnel design. Until 2015, it was painted in the traditional buff colour scheme. (Patricia Dempsey)

Above right: One of *Oriana*'s lifebuoys. 'Hamilton' refers to her port of registry in Bermuda.

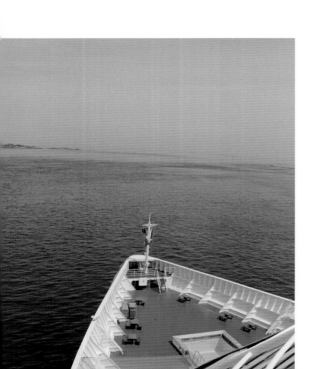

The view over *Oriana*'s bow as seen from her Sun Terrace. Note the crew swimming pool and netted basketball courts on the deck.

In 1979 and then again in 1984, I was a guest speaker on the original *Oriana*. She was a special ship, hugely popular and run in that classic British liner mode: deck games, quizzes and teatime (but in the dining room) by day; quizzes, frog racing and ballroom dancing by night. Many of the officers had long histories with P&O and the Goanese waiters and stewards could trace back generations of service with the company. There were tea trays brought to cabins before breakfast, elevenses, a once-a-voyage deck buffet, and lots of Indian curries worked into the dinner menus.

In 2000, the World Ship Society, Port of New York Branch, was invited to visit the current *Oriana*. Many of us then referred to her as the 'new' *Oriana*. Modern looking on the outside, she was delightfully decorated and 'very British' on the inside – warm, even cosy, and certainly inviting. Many of us were charmed and I had hoped to one day sail in her, but that has not come to pass.

These days, *Oriana* is a very popular member of the P&O Cruises' fleet and has her own corps of devoted followers. With time, she has also become something of a classic, a 'grand ocean liner'. I am therefore delighted and grateful to dear friends and fellow authors Chris Frame and Rachelle Cross for creating this fine tribute to a great P&O liner. Over the years, their work has been brilliant – documenting and acknowledging both bygone liners and current ones.

Long may *Oriana* continue to sail and long may Chris and Rachelle provide us with wonderful books on the great passenger ships!

Bill Miller

INTRODUCTION

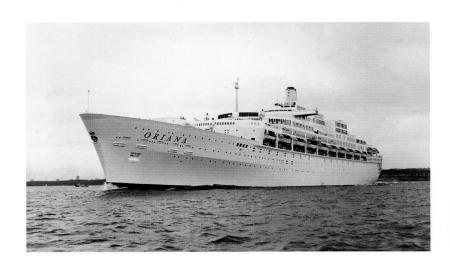

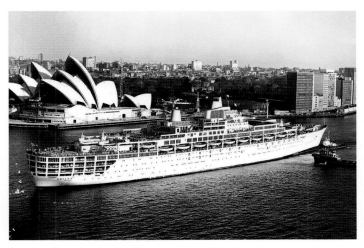

The current *Oriana* was named for an earlier P&O ship of the same name. The first *Oriana* entered service in 1961. Ordered by and built for the Orient Line, she joined the fleet soon after the merger of the P&O and Orient Line brands, which formed P&O Orient Lines Limited.

P&O-Orient's *Oriana* was built at Vickers-Armstrongs in Barrow-in-Furness and was launched on 3 November 1959 by HRH Princess Alexandra. Originally built as an ocean liner, she was very successful.

She was paired with P&O's equally popular *Canberra* on the England to Australia service, but ultimately was overtaken by the jet airliner, which rendered most traditional liner voyages unprofitable.

Having absorbed Orient Line in the 1960s, P&O converted *Oriana* from an ocean liner to a one-class cruise ship in 1973. In this role she pioneered a number of cruise itineraries in the South Pacific, and from 1981 until 1986 she operated cruises from Sydney, Australia.

Above left: The original *Oriana* making her way out of Sydney Harbour. (Henderson & Cremer)

Above right: Launched in 1959, *Oriana* was Orient Line's final ship to enter service after P&O and Orient Line merged; she is shown here next to the Sydney Opera House. (Henderson & Cremer)

Oriana of 1995 in her original P&O livery of white hull and buff funnel. (Patricia Dempsey)

The first *Oriana* was retired in 1986 and became a floating hotel and tourist attraction in Osaka, Japan. She was later sold on to Chinese interests but has since been scrapped. In contrast, *Canberra* remained in P&O service, benefitting from the increasing demand of a growing British cruise market.

On 11 March 1993, P&O officially commenced work on a new *Oriana*. This ship was to be the biggest cruise ship in the P&O fleet and was code-named Project Gemini.

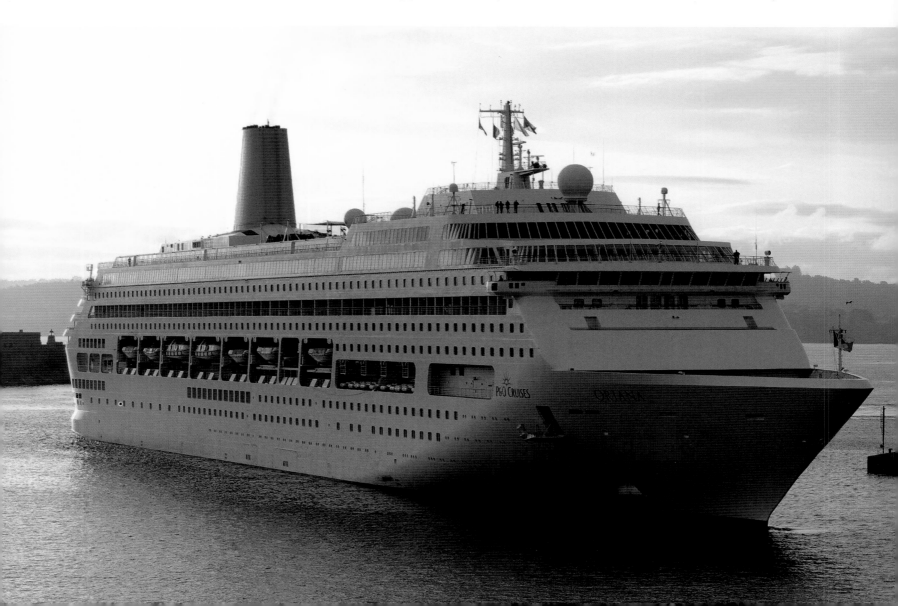

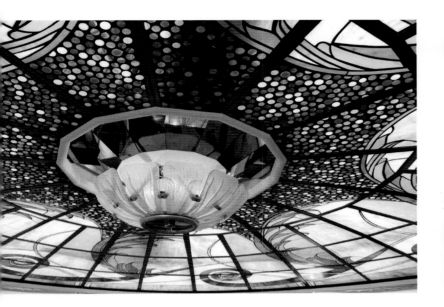

Built at Meyer Werft shipyard in Papenburg, Germany, *Oriana* was created specifically for the British market and would ultimately replace *Canberra*. P&O were quick to ensure that the design incorporated many features of *Canberra*, whilst adding an array of modern technologies and creature comforts unheard of when the older liner was built in the 1960s.

As such, *Canberra*'s external features influenced many of the design choices made aboard *Oriana*. Notable traits include *Oriana*'s terraced stern decks, as well as the promenade deck, which gave the vessel a traditional ocean liner appearance, despite *Oriana* being built specifically for the cruise market. Furthermore, *Oriana*'s single funnel had a distinctive shape, created as a tribute to *Canberra*'s unique twin funnel arrangement.

At the time of *Oriana*'s construction, the British cruise market was still developing. Caribbean cruise ships dominated the order books in worldwide shipyards. But *Oriana* differed in design from many of her cruise ship contemporaries, as she was not being built for the relatively sheltered Caribbean routes. *Oriana* needed to have the ability to cross the Bay of Biscay, which is a deeper sea channel and prone to rough weather.

Above left: The stunning Tiffany glass ceiling in *Oriana*'s Atrium has been a key feature of her interior design since she entered service in 1995.

Above right: Oriana's tenders carry her name and are used to ferry passengers to and from shore while at anchor ports.

The need to transit this waterway, even in winter, led to a decision to give *Oriana* a powerful power plant that would allow her to achieve greater speeds. Though not as fast as *Canberra*, she did take the Golden Cockerel trophy from her predecessor on *Canberra*'s retirement in 1997 and has remained the fastest ship in the P&O Cruises fleet throughout her career.

Delivered to P&O Cruises on 5 April 1995 the ship was officially named by HM Queen Elizabeth II while alongside in Southampton. The new P&O Cruises flagship undertook her maiden voyage, departing on 9 April 1995 under the command of Commodore Ian Gibb. Instantly successful, she managed to bridge the gap between the traditional *Canberra* passengers and a new breed of modern British cruiser.

A view over the bow of *Oriana* as she makes her way into Southampton.

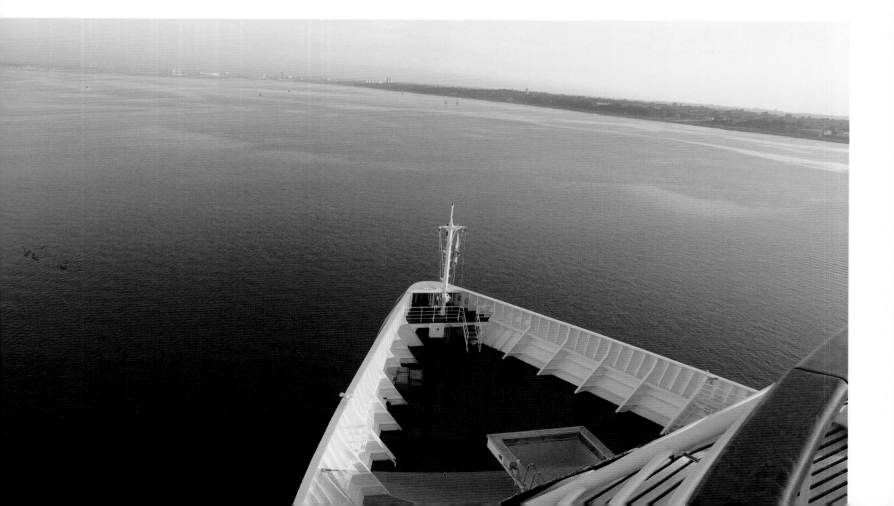

In 2000 a fleet mate, *Aurora*, joined her. Built at the same shipyard as *Oriana*, the larger *Aurora* shares many design features of her elder sister, including the popular terraced aft stern.

Together *Oriana* and *Aurora* carried the P&O name into the twenty-first century, strengthening the brand's reputation within the British cruise market. The success of P&O's cruising operation ultimately contributed to its amalgamation with Carnival Corporation in 2003.

Operated from Carnival UK's Southampton base, *Oriana* has become a firm favourite in the P&O Cruises fleet. Smaller than many of her successors, the ship is today classed as 'mid-sized'. Yet, at 69,840 tons, she is by no means small, and her spacious and airy design has seen her age well in the years since her maiden voyage.

The ship's public areas have been lovingly maintained over the years, thanks to a number of refurbishments. However, one of the biggest changes to *Oriana*'s identity was during her 2011 refurbishment when the popular family-friendly vessel was adapted to become an adults-only cruise ship. This new designation came with twenty-seven new cabins in the space that had been previously allocated to the children's activity areas. A new seating area was built around the Terrace Pool, in the area where the children's swimming pool once resided, while a general update of the facilities aboard was undertaken to position the ship for its new over-18s demographic.

From 2014, P&O Cruises updated its corporate identity. The buff-colour funnels, which had been a P&O hallmark since the 1930s, gave way to a new dark blue colour scheme. *Oriana* received the new colours in early 2015, which were complemented by a stylised Union Flag on her bow.

In 2016 *Oriana* underwent a major facelift in Hamburg, Germany. This refurbishment updated the ship's interior fit-out, complementing the existing layout with new carpeting, drapery, upholstery and lighting. Notable changes aboard included the addition of a 'living wall' in the ship's Atrium, as well as the introduction of the Sindhu Restaurant as the premium extra-tariff offering on board in the ship's highly regarded Curzon Room.

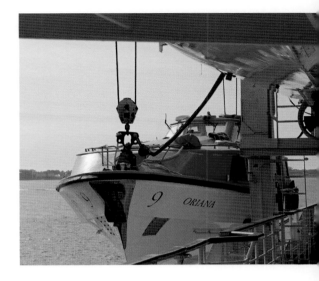

Even the tenders are elegant in their design: here is boat number 9 being lowered during a 2018 call at Guernsey.

Did you know:

Oriana's build number was 636.

Oriana has a maximum service speed of 24 knots.

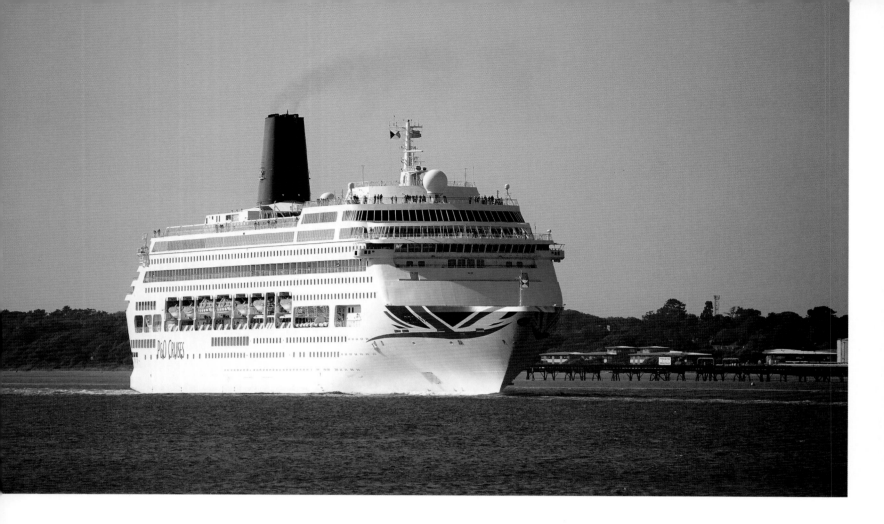

Oriana departing Southampton in 2018. It will be an emotional day for many of her regular travellers when she makes her final P&O departure in 2019.

In 2020 *Oriana* would have celebrated her twenty-fifth anniversary in P&O Cruises' service. Yet, to the surprise of many, in June 2018 P&O Cruises announced that the ship had been sold and will be leaving the fleet in August 2019.

The response has been emotional from those who love *Oriana* and the classic style of cruising that she offers. As the ship commences her farewell season, the emotion will surely continue until the last member of her P&O Cruises crew leaves the ship.

The impact that *Oriana* had on British cruising cannot be underestimated. *Oriana* was the first large-scale new-build designed specifically for British cruising, and she bridged the gap between the eras of the ocean liner and modern-day cruising.

WELCOME ABOARD

When embarking on *Oriana*, the Atrium is the first major interior space that most passengers see. It provides a grand first impression, spanning four storeys in height and dominated by a wall of greenery. The crowning feature of *Oriana*'s Atrium is the Tiffany glass ceiling, which illuminates the space and provides a strong sense of elegance to the area.

Passengers can travel between decks by using the single curved staircase, set at the aft of the Atrium. The staircase ascends from F Deck to D Deck, with a landing between each deck offering vantage points to admire the view.

The main embarkation point for *Oriana* is on F Deck, which is where the Reception Desk is located, while the Promenade Deck is a secondary embarkation point.

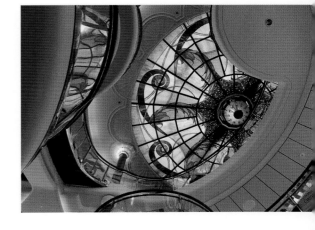

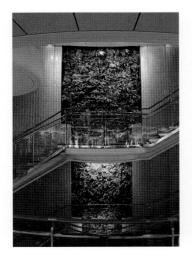

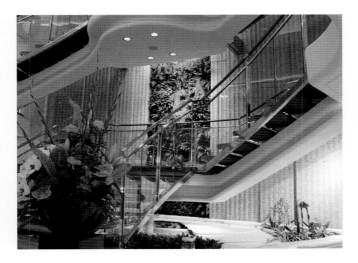

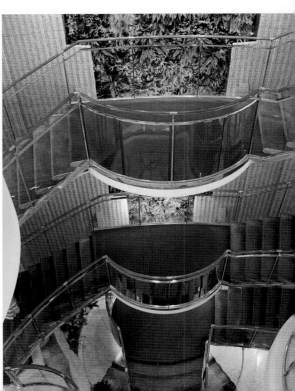

Did you know:

Prior to *Oriana*'s 2016 refit, the main focal point of the Atrium was a four-storey waterfall, which was in the location now taken up by the 'living wall'.

ACCOMMODATION ABOARD ⟲

Your home away from home, *Oriana*'s accommodation is located over six passenger decks. The rooms range from single-berth inside cabins to spacious balcony suites with price tags that reflect the room size and its features.

Regardless of cabin category, each room offers tea- and coffee-making facilities, an in-room refrigerator, en-suite bathroom and a writing desk.

Daily cleaning and turndown services are provided courtesy of the room steward or stewardess assigned to each room.

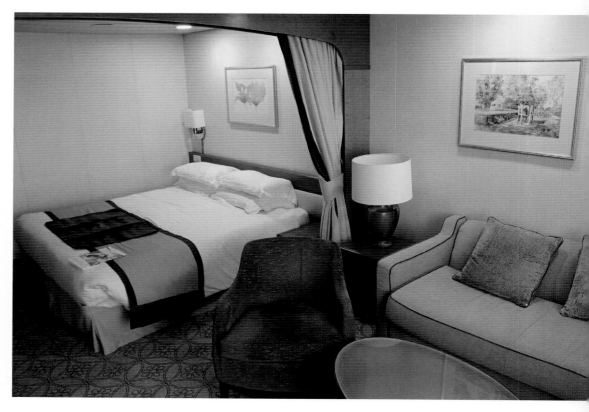

SUITES ∽

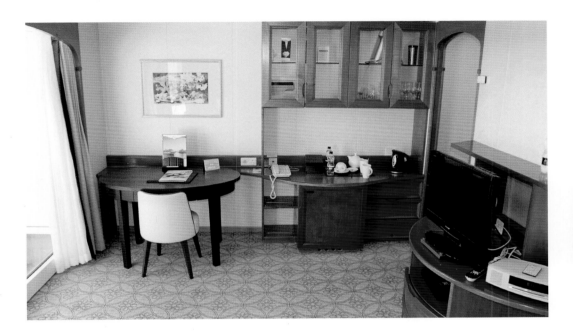

Oriana has eight suites and sixteen mini suites, all located on B Deck. These are the highest-rated cabins aboard Oriana and are the most spacious and well-appointed rooms on the ship.

The suites come with a bedroom, separate lounge area, large balcony, luxurious bathroom and a walk-in robe. Those staying in this level of accommodation have access to a butler service. While smaller in size, the mini suites offer a comparable level of luxury, and all rooms in this category are fitted with a whirlpool bath.

Each of the suites and mini-suites takes its name from a former P&O liner.

Daily canapés are provided to passengers in both the suites and mini suites. Passengers in these rooms will be delighted to find fruit, flowers, chocolate and champagne in their room upon embarkation.

Did you know:

Oriana's suites are named Chusan, Carthage, Hindostan, Himalaya, Sunda, Nyanza, William Fawcett and Valetta.

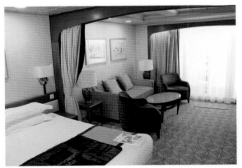

Did you know:

The mini suites are named Medina, Trident, Stratheden, Ophir, Mooltan, Macedonia, Ceylon, Britannia, Caledonia, Canton, Commonwealth, Malwa, Nepaul, Strathfield, Tanjore and Vectis.

BALCONY CABINS ⌇

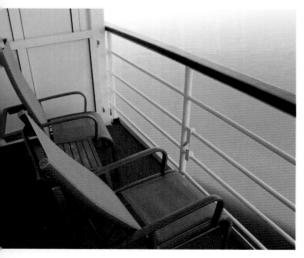

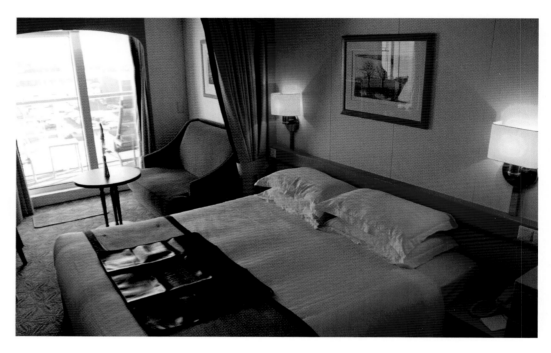

When *Oriana* entered service in 1995, balcony accommodation was generally restricted to the highest grades of cabins. Despite this, *Oriana* was fitted with a whole deck of balcony cabins. Situated on B Deck, these have since been supplemented with additional balcony cabins on D Deck, added during her 2011 refit.

Balcony cabins are spacious and airy, with a seating area that can be curtained off from the main bedroom. Balconies span the width of the cabin and come equipped with recliner chairs and a table.

Each room has a queen bed, which can be converted into two singles, while some rooms can accommodate up to four people with fold-out sofa beds.

While all of the original balcony cabins offer a shower and bath, the twelve rooms on D Deck offer shower only.

OUTSIDE CABINS

Outside cabins aboard *Oriana* offer travellers a view while remaining more affordable than a balcony option. *Oriana*'s mid-'90s design means that outside cabins are the most numerous across the ship.

These cabins are found across all passenger accommodation decks. Most of them include a large picture window, though those at the forward end of E and F Decks have portholes.

Queen beds are available, which can be converted into two singles, while a number of outside rooms can accommodate a third or fourth passenger in the way of a single sofa bed or two pullman beds.

The largest of these rooms, referred to as the 'deluxe outside', feature a separate seating area that can be curtained off from the bedroom, offering an extra level of privacy for travellers – a welcome feature on longer voyages.

All outside cabins on A, B and C Decks have a shower over a bath, while those on D, E and F Decks offer showers only. Regardless of which outside room you choose, your cabin will feature a writing desk, vanity, telephone, tea- and coffee-making facilities and a flat-panel TV, as well as a daily turndown service.

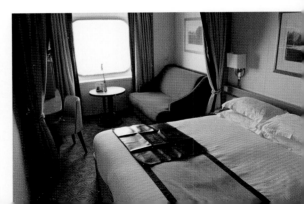

INSIDE CABINS

Located across all passenger accommodation decks, inside cabins offer an affordable cruise experience.

Each cabin offers around 12.7 to 16.5m² of space and includes a queen bed (or two singles), vanity, writing desk, tea- and coffee-making facilities and room service.

The rooms feature a small but well-appointed bathroom. Here you'll find a shower, sink, two medicine cabinets and a vacuum-flush toilet.

Some of the inside rooms can accommodate up to four passengers, with upper pullman bunks. Additionally, *Oriana* offers two inside single cabins for those travelling alone; these are the only single rooms aboard the ship.

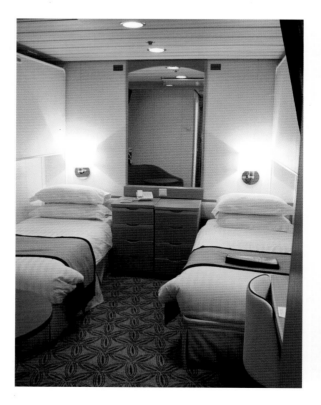

RESTAURANTS ABOARD ᕫ

In addition to providing room service, *Oriana* offers passengers numerous dining options for those travelling aboard. And why would you want to stay in your room when the dining venues present so much variety, as well as an opportunity to meet and mingle with fellow passengers?

Oriana has two separate formal dining venues: the more traditional Oriental Restaurant and the open-seating Peninsular Restaurant. In addition to these, there are two separate buffets and two extra-tariff restaurants.

Overall there is plenty of choice, allowing you to customise your dining experience on each day of your cruise.

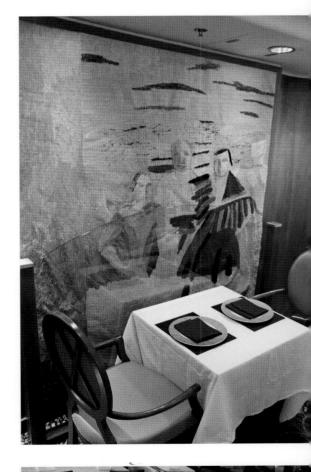

RESTAURANT PROFILE

NAME	LOCATION
Peninsular Restaurant	E Deck
Oriental Restaurant	E Deck
The Conservatory	Lido Deck
Al Fresco	Lido Deck
Sindhu at the Curzon Room	D Deck
The Beach House	Lido Deck

Above right: Sindhu at the Curzon Room.

Below right: Oriental Restaurant.

PENINSULAR RESTAURANT ⟬

Located on E Deck, amidships, the Peninsular Restaurant offers P&O's 'freedom dining' option. This is essentially an open-seating concept where passengers are able to choose the time of dining and number of dining companions at each meal.

The Peninsular Restaurant takes its name from the 'P' in P&O. It has views over both the port and starboard sides of the ship, with large windows offering a spectacular view and a large mural depicting the journey of Odysseus on the aft wall. Decorated with warm tones and dark woods, this restaurant feels elegant and comfortable.

Seating over 500 passengers, the Peninsular Restaurant is open for breakfast, lunch and dinner, and also opens for a traditional English afternoon tea, with finger sandwiches, scones and cakes.

ORIGINS OF PENINSULAR: The Peninsular Steam Navigation Company (PSN Co.) commenced trading in 1835 between Britain and the Iberian Peninsula, with a fleet of three steam ships. In 1840 PSN Co. was reorganised as a limited liability company and renamed the Peninsular and Oriental Steam Navigation Company (P&O).

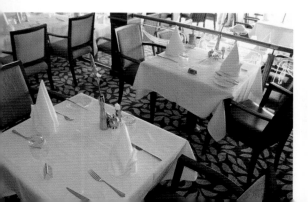

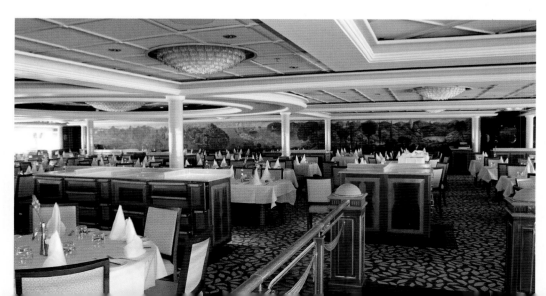

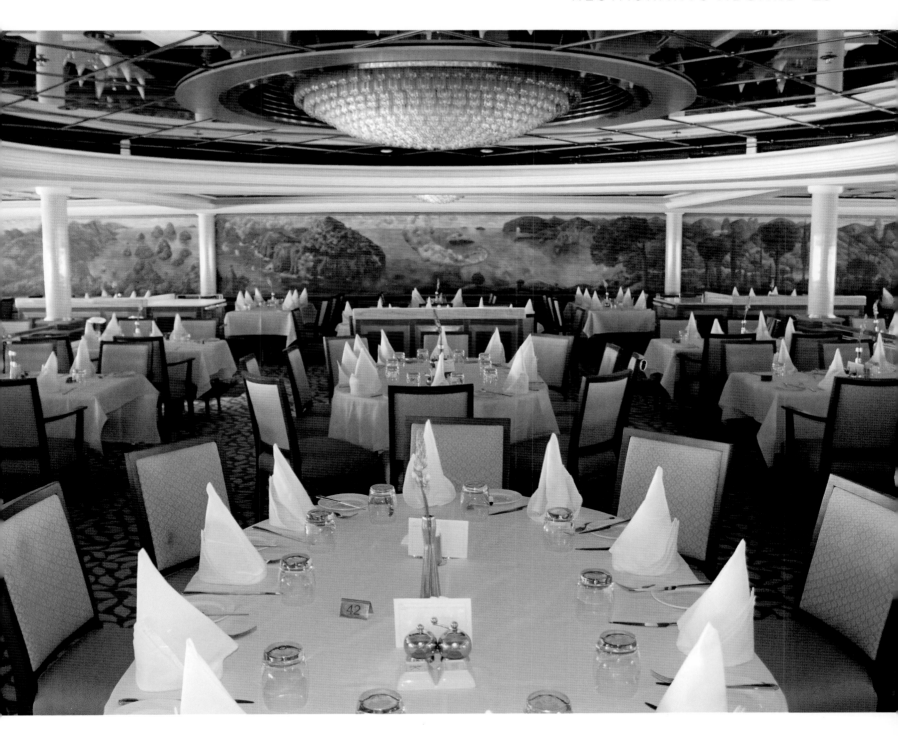

ORIENTAL ∽

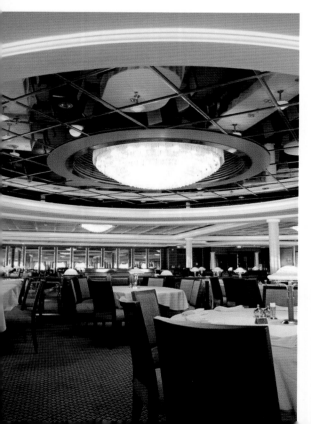

The 'O' in P&O stands for 'Oriental' and was added in 1840 as the young company set its sights on eastward expansion into India and Eastern Asia. It is from this historical connection that the Oriental restaurant takes its name.

Located on E Deck, the restaurant is situated aft, offering sweeping views not only to the port and starboard sides, but also out over the wake. This is a common feature among modern cruise ships, but it was a novelty when *Oriana* was first introduced in 1995.

Decorated in a traditional style with dark woods, mirrored ceilings and gold trim, the Oriental restaurant provides set-seating dining. Marketed as 'club dining', passengers choosing to eat in this restaurant will be assigned a table for the duration of their cruise, allowing them to enjoy the same waiters and dinner companions throughout their holiday.

Seating close to 500 diners, this venue is only open for dinner, with two available seatings: an early seating at 6.30 p.m. and a late option at 8.45 p.m.

ORIGINS OF ORIENTAL: The Peninsular and Oriental Steam Navigation Company was incorporated by Royal Charter on 31 December 1840. Previously called Peninsular Steam Navigation Company, the addition of the word 'Oriental' reflected the company's plans to expand their network beyond the Mediterranean.

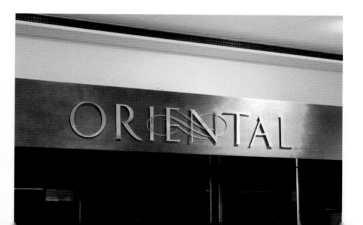

Did you know:

The first 'Oriental' route the company plied was between Egypt and India, and commenced in September 1842, with the repositioning of *Hindostan* to the Red Sea.

THE CONSERVATORY

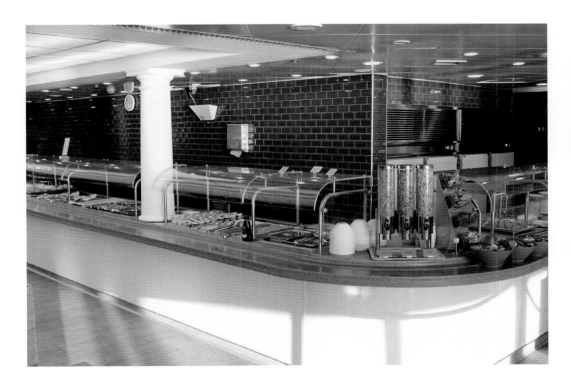

Food abounds in The Conservatory, with a varied buffet available to satisfy your hunger. Found at the aft end of Lido Deck, the restaurant is the main self-service dining venue aboard *Oriana*.

Styled in blues and cream and complemented by light wooden furniture, The Conservatory has a bright and airy feel, bolstered by large windows overlooking the sides of the ship.

Decorative brushed-brass screens and deep blue padded bench seats break this large space into zones, offering an informal and uncrowded feel. A central buffet is laid out in an easy to navigate style, with a wide selection of foods including everyday favourites and daily specials.

Overheard in The Conservatory:

'Do the crew live on board?'

AL FRESCO

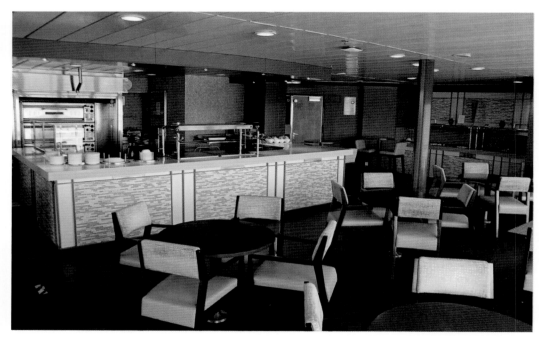

The Al Fresco restaurant at the forward end of Lido Deck offers both indoor and outdoor seating. An ideal location to grab a bite to eat when sitting by the Riviera Pool or when the weather is fine, this restaurant has a very casual and relaxed ambiance.

Open for breakfast and lunch through to early evening, the Al Fresco restaurant is *Oriana's* secondary buffet restaurant. It serves lighter meal choices and snacks throughout the day, including sandwiches, soups, salads and pastries.

SINDHU AT THE CURZON ROOM ⟡

The specialty restaurant aboard *Oriana* is Sindhu. Sindhu is located on D Deck, amidships, in *Oriana*'s Curzon Room. This restaurant serves Indian themed cuisine and is a popular alternative dining option for passengers wishing to try something different from their usual assigned restaurant.

Sindhu's menu has been created by Michelin-starred chef Atul Kochhar and is prepared on-board by *Oriana*'s chefs, many of whom were trained by Kochhar.

The restaurant itself is decorated in rich tones, with intricate chandeliers providing an atmosphere that differs from all other areas on the ship.

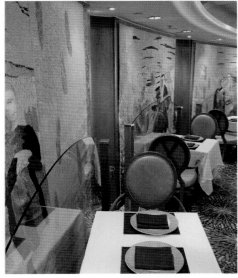

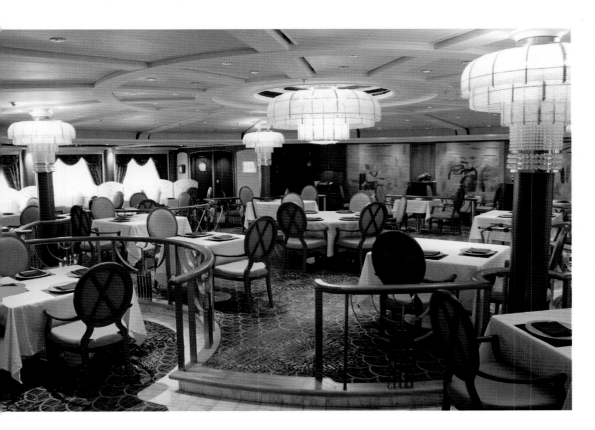

Did you know:

The Curzon Room aboard *Oriana* has had a number of different incarnations over her years in service. Originally the Curzon Room was a lounge for classical concerts. This was altered during 2006 to create the Oriana Rhodes, named for celebrity chef Gary Rhodes, who oversaw the menu. In 2011 it became the Ocean Grill, with celebrity chef Marco Pierre White creating the new menu. The current incarnation, Sindhu, was created during *Oriana*'s 2016 refurbishment.

THE BEACH HOUSE

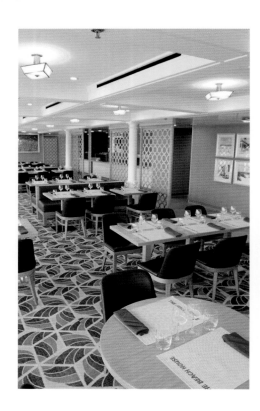

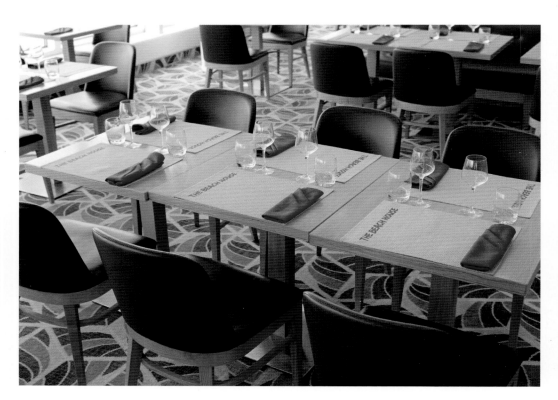

One of the two extra-tariff restaurants aboard *Oriana*, The Beach House serves an international style menu, in a laid-back and casual setting.

The Beach House is open for dinner only, being part of The Conservatory Restaurant during the day. Situated at the aft end of The Conservatory, the seating for The Beach House also extends outside onto the Lido Deck by the Terrace Bar.

Dining at this restaurant attracts a charge per person, with some choices on the menu, such as lobster tail or specialty kebabs, attracting an additional charge.

BARS AND LOUNGES

One of the great pleasures to be had on a cruise holiday is the opportunity to relax and unwind with a drink. Whether that drink is your morning coffee, a mid-morning smoothie or an evening cocktail, *Oriana* has a range of bars and lounges in which you can indulge.

Situated across multiple decks, *Oriana* provides an array of indoor and outdoor bars and lounges, allowing passengers the opportunity to enjoy a peaceful drink, whatever the weather.

BARS AND LOUNGES PROFILE

NAME	LOCATION
The Crow's Nest	Sun Deck
Medina Room	Sun Deck
Riviera Bar	Lido Deck
Terrace Bar	Lido Deck
Tiffany's	D Deck
Sunset Bar	D Deck
Anderson's	Prom Deck
Harlequins	Prom Deck
Lords Tavern	Prom Deck
Pacific Lounge	Prom Deck

Did you know:

Vangelis' 'Conquest of Paradise' was played when *Oriana* was handed over to P&O Cruises in Germany.

THE CROW'S NEST ᐰ

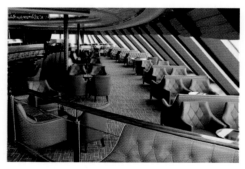

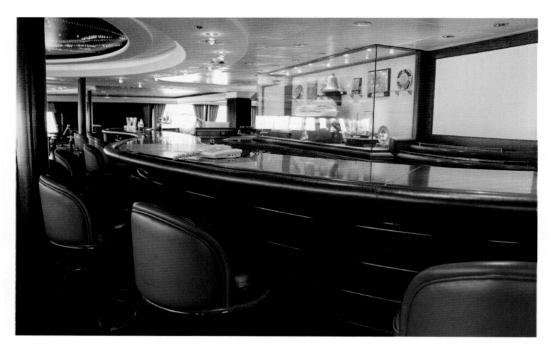

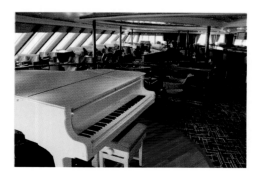

As its name implies, The Crow's Nest is located at the top of the ship, on Sun Deck. The Crow's Nest is *Oriana*'s observation lounge and bar and is located at the forward end of the ship with views over the bow and sides of the vessel.

The Crow's Nest has a split-level design, which enables even those seated away from the windows to still have a view through the glass that forms three sides of the room. A white baby grand piano holds pride of place on the port side of the room; it's used most evenings for musical entertainment both before and after dinner.

As *Oriana* was built to replace P&O's ageing *Canberra*, this bar was inspired by the popular venue of the same name aboard her older fleet mate. It has since been included on many other P&O Cruises vessels.

THE MEDINA ROOM

Located just aft of The Crow's Nest, on the starboard side of the ship, you'll find The Medina Room. The room takes its name from the earlier P&O vessel, *Medina*, which was requisitioned in 1911 as a royal yacht and used to convey King George V and Queen Mary to Delhi, India, for the Durbar.

The Medina Room is an intimate lounge on board the ship and is popular for quiet conversations and reading. Though the room does not have its own bar, its close proximity and adjoining door to The Crow's Nest means it is still popular for those wishing to partake in a quiet drink.

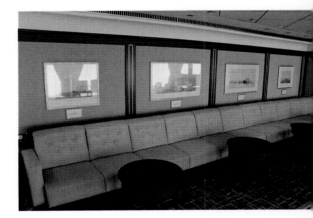

HMY *MEDINA*

As part of *Medina*'s refurbishment to serve as a royal yacht, the ship was fitted with a special third mast.

This allowed the Royal Standard to be flown in the traditional style.

The ship was also painted white, with a blue band around her hull, while her interiors were significantly altered to accommodate the royal party.

RIVIERA BAR ༄

The Riviera Bar is situated just forward of the Riviera Pool on Lido Deck, from which it takes its name. This is an open-air bar that serves drinks to those seated anywhere in the Riviera Pool area.

The bar is located under cover, with some shade provided to those who choose to sit at the bar. There are tables and chairs placed in the shaded areas, but for those wishing to enjoy the sunshine, there are deck chairs arranged around the nearby pool.

The bar itself is wood-panelled with bright blue tile detailing. As the Riviera Pool and Bar area is somewhat sheltered from the wind, this is a popular venue for an on-deck drink when the weather conditions make some of the other on-deck locations less appealing.

Did you know:

The Riviera Bar is very popular during the Great British Sail Away.

TERRACE BAR ୬∿

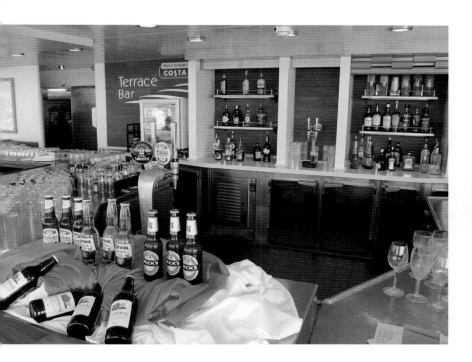

The Terrace Bar offers a fantastic view of the aft of the ship and its wake, all from its high perch on Lido Deck.

Taking its name from *Oriana*'s terraced stern, the Terrace Bar sits at the topmost deck of the terraced area. As a result, it offers an excellent vantage point to appreciate the classic lines of the ship.

The Terrace Bar has seating for passengers both at the bar and at tables and chairs arranged nearby. It's a great location to view a sail away.

Did you know:

The Terrace Bar is popular not only for its magnificent views and cold drinks, but also for its premium ice cream offering!

TIFFANY'S

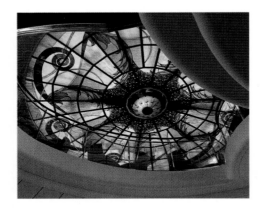

On the top level of the Atrium, directly beneath the Tiffany glass ceiling, is Tiffany's. Tiffany's is *Oriana*'s coffee bar and is popular throughout the day for its Costa coffee, selection of specialty teas and array of mouth-watering cakes.

Though the main focal point of this bar is the impressive glass ceiling and chandelier, the room also features an impressive view of the Atrium and the green wall, which is the main feature of that space.

Tiffany's offers soft and comfortable armchairs around small tables that encourage visitors to sit and relax awhile and engage in conversation, while live music is provided by pianists on a baby grand piano that takes pride of place in the centre of the room.

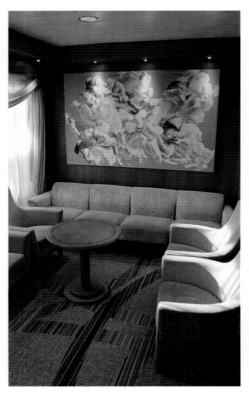

SUNSET BAR ༄

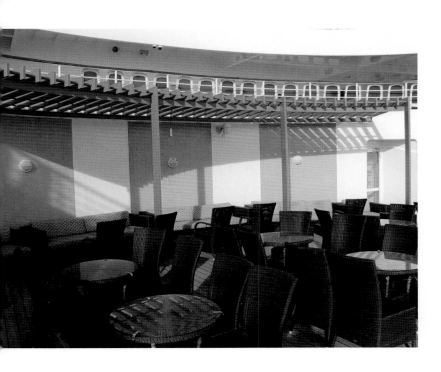
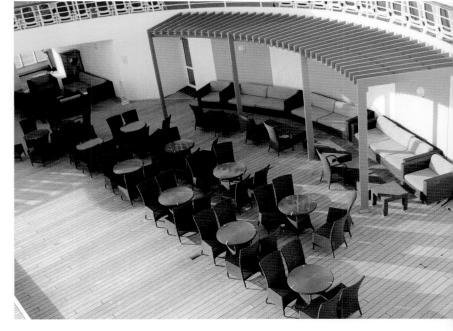

On the lowest deck of *Oriana*'s terraced stern, tucked under the stairs on the starboard side of the ship, is the Sunset Bar. This bar services the decked area surrounding the Terrace Pool.

Those who enjoy a drink outside by the pool, as well as those wanting to take a closer view of the wake of the ship, keep this bar busy on sunny days.

The ambiance is aided by the adjacent semi-shaded seating area, with loungers as well as tables and chairs available.

The Sunset Bar is a popular location when the ship is cruising to unique destinations, such as transiting the Panama Canal, as its low and open vantage point provides unrivalled views.

ANDERSON'S ᡖ

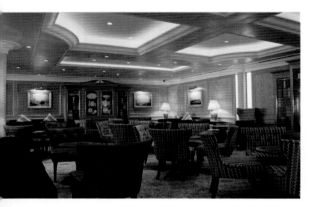

Amidships on Prom Deck is the location of Anderson's, one of the more elegant-looking bars aboard *Oriana*. Anderson's is named for one of the founders of the P&O Line, Arthur Anderson.

Artwork depicting some of the great P&O ships of the line's early career adorn the walls, while a bust of Arthur Anderson is included in the main access way, close to the bar.

Remaining true to the era of P&O's foundation, Anderson's has the ambiance of a nineteenth-century London club, with wood-panelled walls, nautical themed art, and elegant and comfortable seating. Its design and feel, as well as its close location to *Oriana*'s casino, make Anderson's a favoured bar for many passengers throughout their cruise, while it doubles as a quiet and relaxing lounge during the day.

Look closely

Although Anderson's is named for P&O founder Arthur Anderson, the room also pays tribute to his business partner Brodie McGhie Willcox. A sound businessman, Willcox was equally vital to P&O's formation and a large portrait of him is displayed in this room.

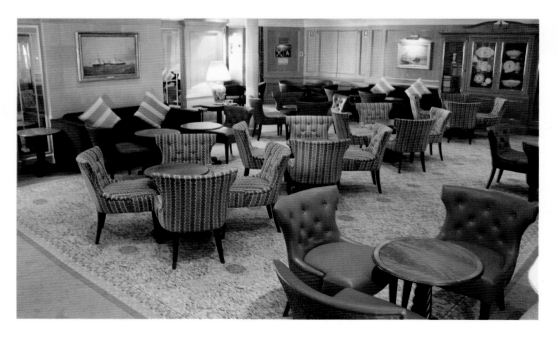

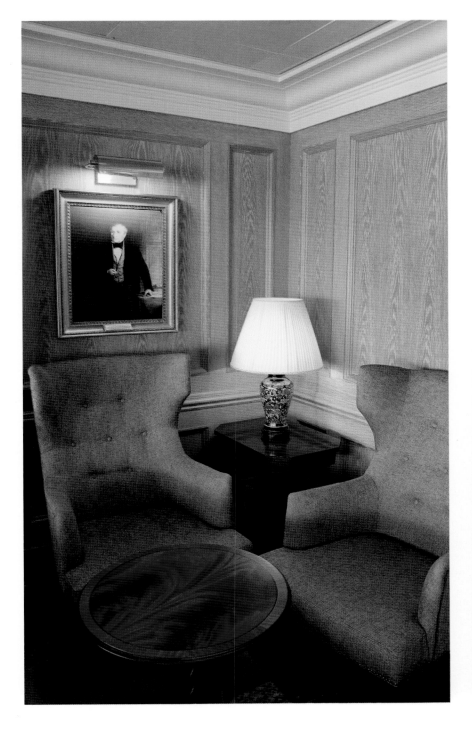

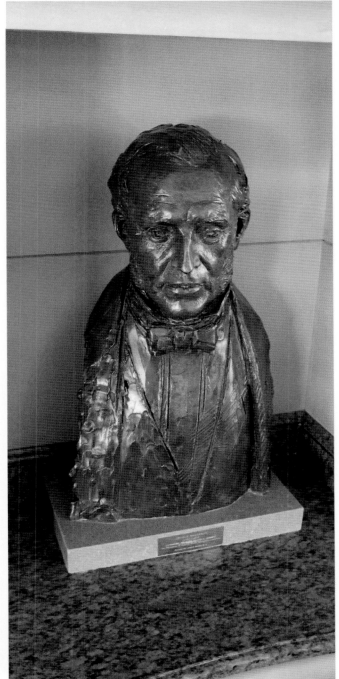

HARLEQUINS ෨

If you want to dance the night away, head to Harlequins. Located amidships on Prom Deck, Harlequins is accessed from the port side internal promenade.

Harlequins functions as *Oriana*'s nightclub, offering either live music from one of the ship's bands or recorded music from the DJ station. It has a large dance floor, which sits under a disco ball suspended from an illuminated decorative ceiling.

Harlequins offers seating on split levels for those who wish to recover between dances, or those wanting to take in the atmosphere without joining in. The starboard wall has large windows that offer a view over the side of the ship.

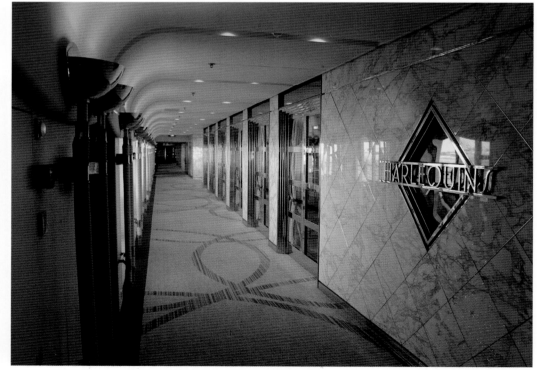

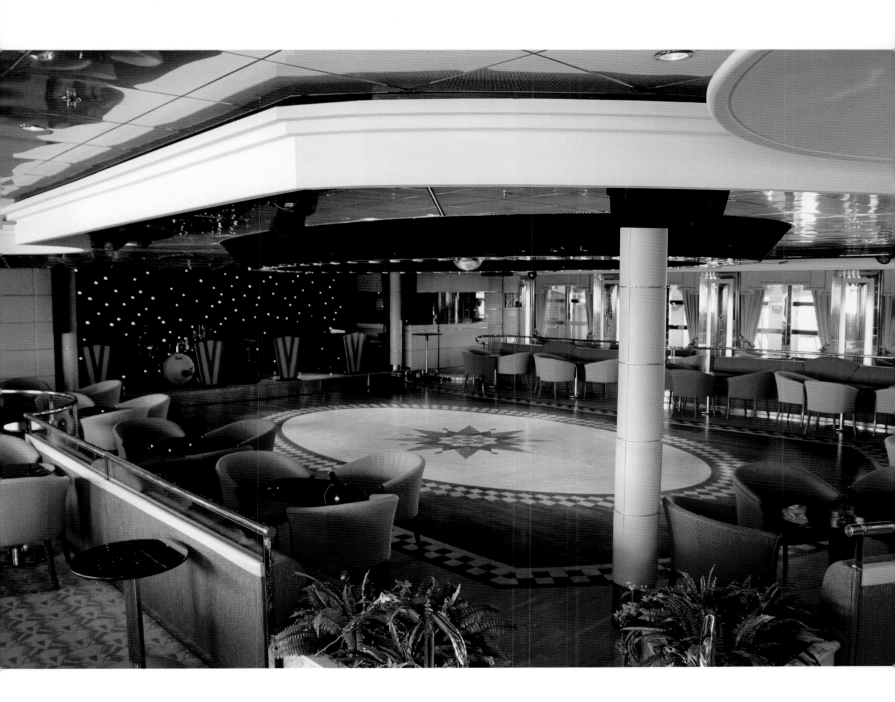

LORDS TAVERN ൟ

Oriana's sports bar, located on Prom Deck, is named Lords Tavern. This room has a strong cricket theme, with a large mural of Lord's cricket ground taking up most of one wall. Here, observant viewers can make out the detail of this artistic work, including the P&O Cruises advertising banners depicted on the stands.

The carpet is primarily green, with the pattern on it resembling the stitching on a cricket ball; the bar itself is situated under a shade sail. The room has the feel of a sports clubhouse and bar, with plenty of sporting memorabilia displayed on the walls, including cricket bats and trophies.

Lords Tavern offers all of the usual expectations of a sports bar, such as large flat-screen televisions for watching sporting events, pub quizzes and a wide selection of beers and ales on tap. As an added bonus, there are traditional wooden doors leading out onto the Promenade Deck, allowing patrons to wander out into the fresh air with ease.

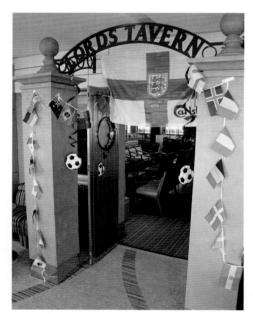

Look closely

Observant visitors to Lords Tavern will notice the room's audio speakers are the shape and colour of cricket balls.

PACIFIC LOUNGE ⌒

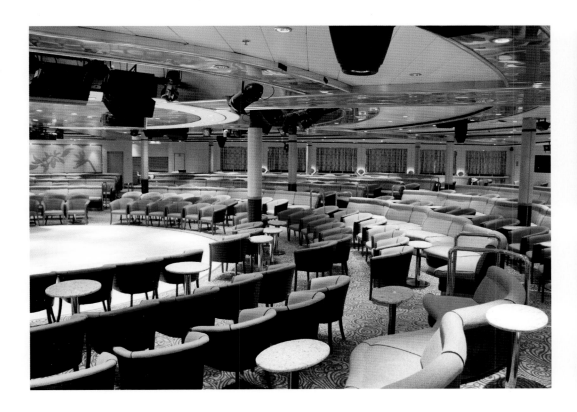

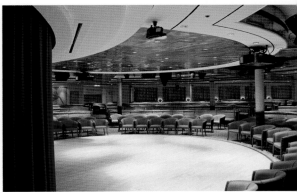

Located at the aft of Prom Deck is the Pacific Lounge. This is the smaller of *Oriana*'s two show lounges and is used as a general lounge but also as a venue for live performances and lectures.

The Pacific Lounge features tub-style chairs, with small tables that allow patrons to rest their drinks whilst they enjoy the show. The seating is slightly tiered to provide good sight lines for all in the room.

This lounge serves drinks at show times only, and at other times is usually quiet, leading some passengers to use this room to read or catch up on email correspondence using the ship's WiFi.

PUBLIC AREAS

PUBLIC AREAS PROFILE

NAME	LOCATION
Oasis Spa & Salon	Lido Deck
Gym	Lido Deck
Wedding Venue	B Deck
Crichton's Card Room	D Deck
Thackeray Room & Cyb@Study	D Deck
Library	D Deck
Chaplin's Cinema	D Deck
Theatre Royal	Prom Deck
Explorers	Prom Deck
Future Cruise Sales & Loyalty	Prom Deck
Knightsbridge & Emporium	Prom & E Decks
Monte Carlo Club	Prom Deck
Photo Gallery	Prom Deck
Reception Desk	F Deck
The Courts	Multiple Decks
Laundrettes	Multiple Decks

At just under 70,000 gross tons, *Oriana* is considered a mid-sized ship in today's fast-growing cruise market. However, *Oriana* still offers a wide range of public spaces for passengers to enjoy. In fact, one of the delightful things about *Oriana* is how much choice has been built into the ship's design, appealing to many different tastes.

From the peace and quiet of the ship's library to the fast-paced excitement of the casino, the dazzling entertainment at the Theatre Royal to the mundane chores undertaken in the Laundrettes, *Oriana* provides spaces that meet all of a passenger's holiday needs.

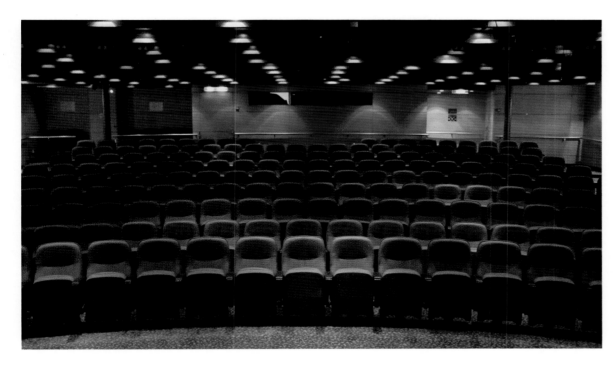

Chaplin's Cinema.

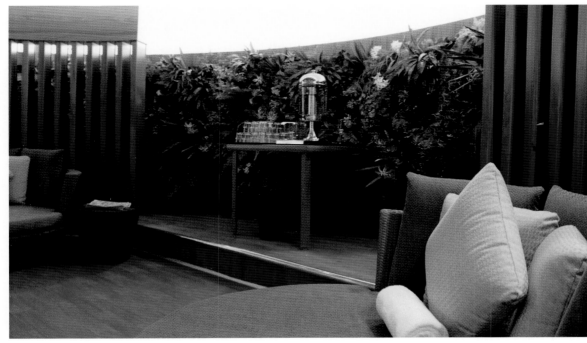

Oriana's Oasis Spa.

OASIS SPA AND SALON 🌀

For many people the appeal of a cruise is a chance to relax, unwind and de-stress. *Oriana* certainly caters for these travellers, with the Oasis Spa and Salon on hand to pamper you.

Found on the port side of the Lido Deck, its forward location offers views over the deck that allow the area to be bathed in natural light. Decorated in a tranquil theme of grey, gold and wood tones, the facility's circular daybeds are surrounded by plants and greenery, including a green wall. Whirlpool spas and a sauna are available, as well as treatment rooms for massages and therapy, while the nearby salon provides hair and beauty services.

Did you know:

The Oasis Spa and the Gym share access to a central sauna.

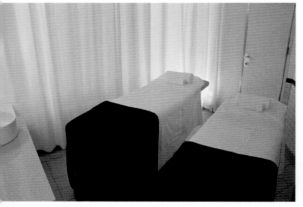

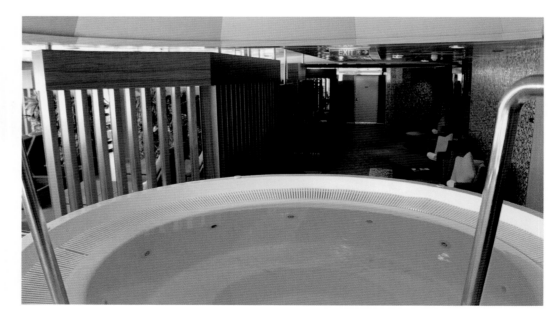

THE GYM

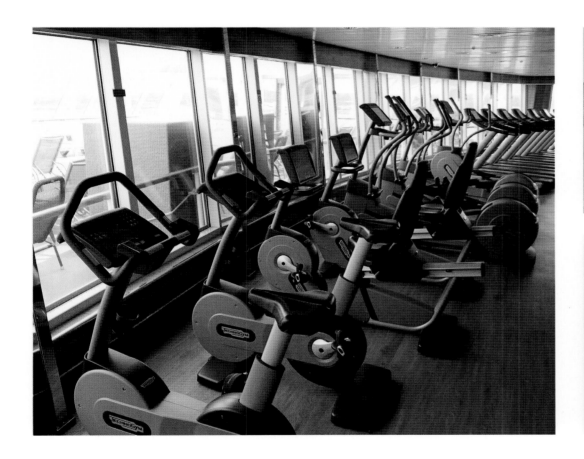

Adjacent to the Oasis Spa and Salon, the Gym is an airy and spacious facility, with views out over the forward and starboard sides of the ship.

This is the place to go to stay fit during your cruise, with aerobics, yoga, Pilates and spinning classes, as well as a weights room. For the more committed there are personal trainers, nutrition experts and even a body-sculpt boot camp. It is therefore theoretically possible to leave the ship in better shape than you joined it!

Did you know:

In 2011 the Gym was expanded into space formerly occupied by the Oasis Spa. This more than doubled the size of the Gym.

WEDDING VENUE ❧

For many, the idea of a cruise holiday is the ultimate in romance. Aboard *Oriana* this can be taken to the next level, with the option to get married on board.

Wedding ceremonies are undertaken in a dedicated wedding venue. Found at the very front of B Deck, the room has a forward-facing view over the *Oriana*'s bow. With large windows, a small altar and chairs set up in rows of four, the venue is decorated with flowers before each wedding. As part of their wedding package, travellers getting married aboard *Oriana* will receive champagne and flowers on arrival, a bottle of champagne to toast their marriage and the services of a wedding coordinator to help plan the big day.

Did you know:

In 2006 *Oriana*'s registration port was changed from London to Hamilton, Bermuda, allowing weddings to be performed on board.

CRICHTON'S CARD ROOM ❧

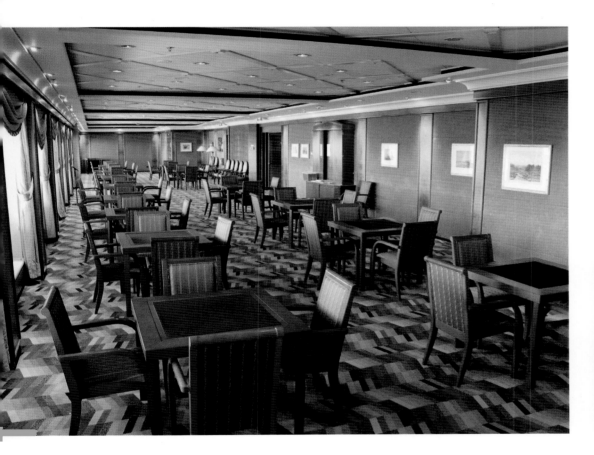

Did you know?

Crichton's Card Room is named for Sir Andrew Maitland-Makgill-Crichton, who was General Manager of P&O from 1951 to 1965.

Lovers of card games will revel in the spaciousness and comfort of Crichton's Card Room. Organised bridge tournaments and quizzes are popular here, while others will enjoy the space to practise other card games.

Located on the starboard side of D Deck, the space has two entry points: one forward near the central stairway, and the other amidships next to the Library. With an ambiance that reflects similar spaces in ocean liners of days gone by, Crichton's is a classic and traditional space that is sure to delight.

THE THACKERAY ROOM ೦൦

Named for the famous nineteenth-century writer William Thackeray, the Thackeray Room is found on D Deck, running alongside the Library. With design and decor reminiscent of the writing rooms found on early P&O liners, this space is popular with readers who want a quiet location to enjoy a good book.

But let's admit it, these days many of us are addicted to technology! While being at sea can provide a welcome respite from the constant digital bombardment, for some the thought of being disconnected just doesn't appeal. To meet those needs, *Oriana* has the Cyb@Study inside the Thackeray Room, with satellite internet and computer terminals. These terminals are found on traditional-style writing tables, complete with individual lamps. Additionally, for those who have brought their own devices, *Oriana* provides a WiFi service throughout the ship.

Did you know:

In 1844 P&O provided William Thackeray with tickets for his grand tour. Considered the precursor to cruising, these grand tours saw adventurous travellers change ships a variety of times to explore destinations throughout the Mediterranean. Thackeray documented his travels in a book called *Notes on a Journey from Cornhill to Grand Cairo*.

Did you also know:

The Cyb@Study was originally located outside the Crow's Nest, but this room has since been converted into a crew training room.

THE LIBRARY ◦◦

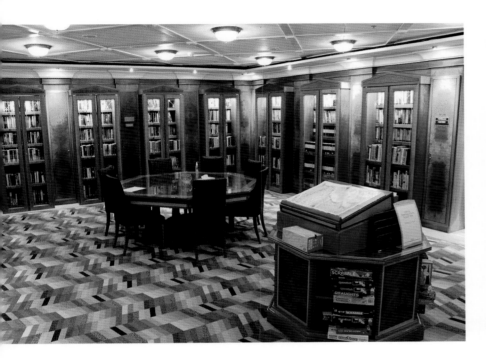

On ocean liners of days gone by, reading a good book on a deck chair was one of the most popular ways to pass the time during a long sea voyage. And, while *Oriana* has a wide variety of entertainment venues to keep her cruising passengers occupied, book lovers will find a tranquil retreat in the ship's Library.

The walls are lined with books in glass-fronted cabinets, surrounded by wood veneer. A large octagonal table takes pride of place in the centre of the room, adding to the traditional shipboard feel. The Library is staffed by trained librarians, and, in addition to the many books that passengers can borrow, there are also board games that can be enjoyed whilst aboard the ship.

CHAPLIN'S CINEMA ⟨∿⟩

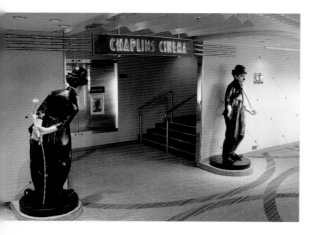

Chaplin's Cinema, as the name suggests, is the dedicated cinema room aboard *Oriana*. It is flanked at its entrance by two statues of Charlie Chaplin, from whom the cinema takes its name.

The ship plays both new releases and old favourites and can accommodate 200 passengers at each show in tiered seating. In addition to showing films, this room is also used as a lecture venue.

Having a dedicated movie theatre aboard a mid-sized ship is somewhat of a rarity these days, as most ships have abandoned the dedicated cinema in favour of more multipurpose spaces.

LOVE THEM OR HATE THEM: The statues at the entrance to Chaplin's Cinema are a subject of great debate amongst passengers. Some people love them for their quirky nature, whilst others find them unbecoming of the rest of *Oriana*'s decor.

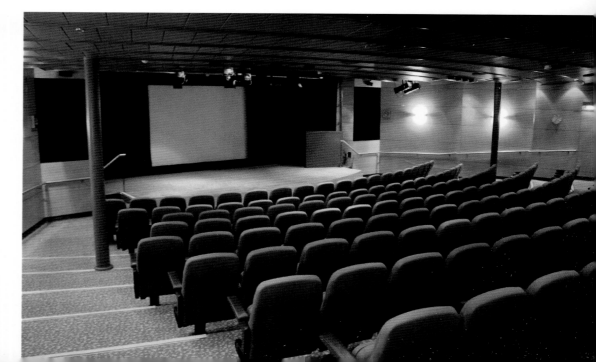

THEATRE ROYAL ⟋⟍

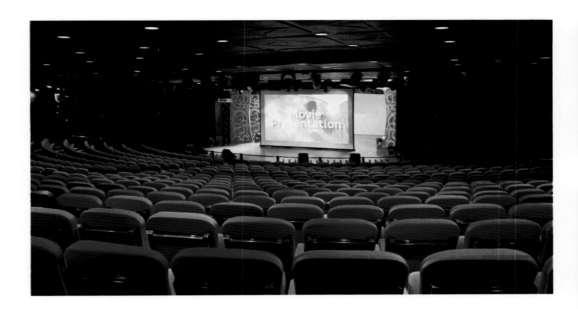

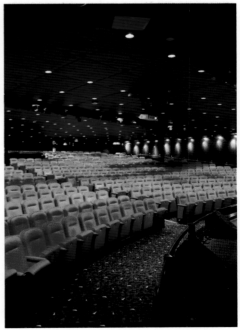

At the forward end of Prom Deck is the Theatre Royal. This 650-seat venue is modelled on the West End and is the primary show lounge aboard *Oriana*. It is a high-tech and modern theatre, decorated in rich colours and dark woods.

The theatre's seating is curved around the stage and offers excellent sight lines from all areas in the room. In fact, when the *Oriana* made her debut in 1995, the Theatre Royal was the first large cruise ship show lounge with no obstructed views.

The theatre's stage has a rotating platform and a sunken orchestra pit (which can be raised if needed). Additionally, lighting and audio have been consistently updated throughout the ship's career, which means that performances in this theatre have a very professional and modern flair.

Oriana has an on-board theatre company, but also plays host to visiting entertainers. As a result, the performances in this theatre are varied and ever-changing, and range from production shows to local entertainment.

Did you know:

The Theatre Royal is the main venue for *Oriana*'s guest lecture program.

EXPLORERS ⟨∿⟩

Look closely:

If you look closely at Explorer's artwork, you'll notice that the images of *Oriana* show the ship with her original buff-coloured funnel.

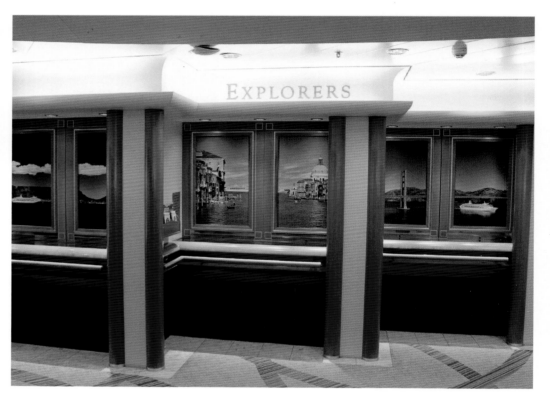

While *Oriana* offers a wide variety of entertainment on board the ship, there is also fun to be had when visiting the various ports of call on your cruise. To help passengers make the most of their stays in the various ports, there is Explorers, P&O Cruises' shore tour office.

Explorers is located on the port side of Prom Deck, just aft of the forward stairway. Here you can find information about *Oriana*'s cruise destinations and the tours available on each cruise. Flat-panel television screens showcase the latest tour information, while passengers can book directly with staff or by using the drop box and booking forms located here.

LOYALTY AND CRUISE SALES

Immediately aft of the shore tour office is the Loyalty and Cruise Sales office. Comprising of two desks discreetly located behind twin wooden-slatted privacy screens, this is the place to go when planning your future travel with P&O Cruises.

Cruise experts are on hand to assist with guest enquiries, while this area is also home to the Peninsular Club, P&O Cruises' loyalty program. Status in this club is attained based on the number of nights spent on board P&O Cruises' voyages, with perks such as priority embarkation reserved for those who travel frequently with the line.

As such, the team at this office not only have the responsibility of booking passengers on future voyages but also for ensuring that the needs of the Peninsular Club members are met whilst they are on board.

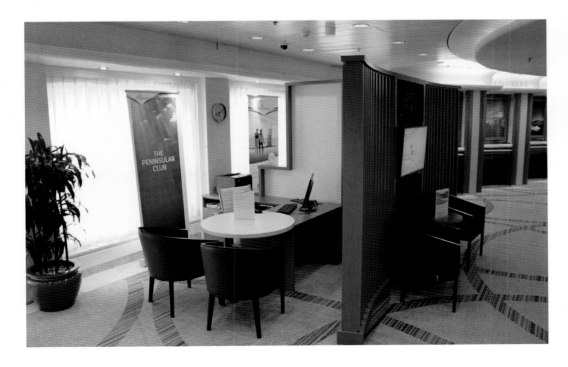

Did you know:

You need to spend at least fifteen nights aboard a P&O Cruises ship before you become a member of the Peninsular Club.

KNIGHTSBRIDGE AND EMPORIUM ᘯ

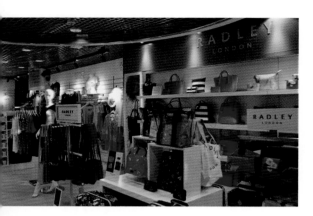

For decades shipboard shops have been prominent features on the deck plans. Originally small spaces dedicated to basic amenities, the transportation boom of the late 1930s saw more and more ships built with shopping promenades that rivalled high streets on land.

Aboard *Oriana*, this tradition is continued with Knightsbridge and Emporium. Located across two decks (Prom and E Decks), the shops offer everything you could need while at sea, as well as tempting treats to take home with you after your cruise.

Found on E Deck, Emporium is the ship's general store, with a variety of items ranging from toiletries and medicines to gifts, trinkets and *Oriana*-branded memorabilia. Perhaps the most popular part of Emporium is its chocolate wall, with a diverse selection of British chocolate treats.

Situated across both Prom and E Decks, Knightsbridge is the main boutique aboard *Oriana*. Here you can peruse a selection of designer wares including handbags, jewellery, watches and clothing.

Despite both decks holding portions of Knightsbridge, the two are not connected, with guests needing to utilise one of *Oriana*'s staircases or lifts to move between decks.

MONTE CARLO CLUB ❧

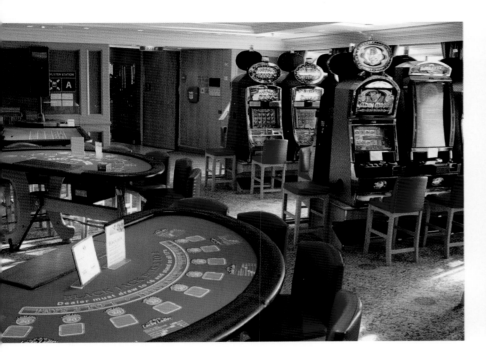
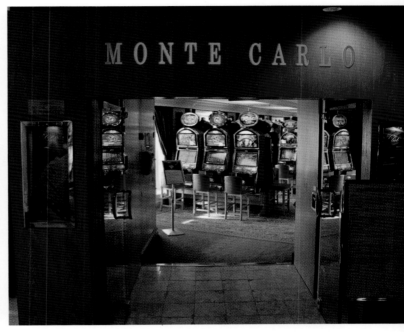

Oriana's casino is called the Monte Carlo Club. Named for the Mediterranean gaming capital, *Oriana*'s casino is located on the starboard side of Prom Deck.

While the casino is not large compared to those aboard many cruise ships, it nevertheless provides a selection of slot machines, as well as a number of gaming tables, allowing travellers aboard *Oriana* to test their luck during their cruise.

The Monte Carlo Club leads onto Anderson's, from where the drinks service is operated. The casino is closed whilst in port but is open until late when the ship is under way.

PHOTO GALLERY ෴

From embarkation to departure there are plenty of chances to capture that perfect photo aboard *Oriana*. This is made all the easier thanks to an expert team of photographers who are at the ready throughout the voyage.

With cameras in hand, the ship's photographers meet embarking passengers, capture images during sail away parties, and attend gala dinners. These pictures can be viewed and purchased at the Photo Gallery. Found on Prom Deck, aft, it acts as a thoroughfare to the Pacific Lounge, meaning nearly every passenger will at some stage pass through.

This is also the location to view and purchase professionally made DVDs of your voyage, buy professional photographs of *Oriana*, or pick up your own photos that you can have printed on board.

RECEPTION DESK ❧

On F Deck, just off the Garden Court, is one of the busiest places aboard *Oriana*: the Reception Desk. Traditionally called a Purser's Office, the Reception Desk is the place to go for all passenger issues and queries throughout your cruise.

With a large, curved granite desk facing aft, the area overlooks the Atrium staircase. Though often a busy hub of activity, it is given a more tranquil atmosphere thanks to the small garden at the base of the stairs.

This area acts as a hotel lobby, concierge, Bureau de Change and information service all in one, with a team of customer service staff on hand to ensure your cruise is trouble-free and enjoyable.

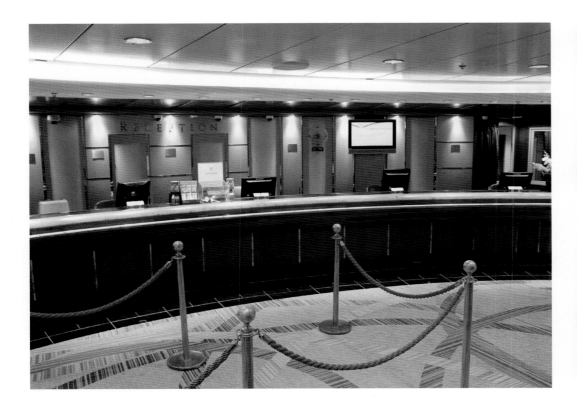

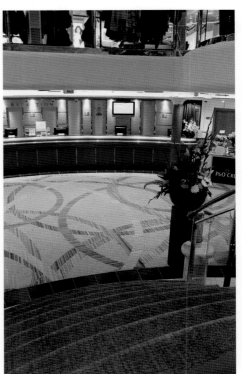

THE COURTS 🌀

The Courts aboard *Oriana* are found on the Atrium stairway landings of D, Prom, E and F Decks.

Tiffany Court takes its name from its location beneath the Tiffany glass ceiling on D Deck. It forms the entrance to Tiffany's bar and is really an extension of Tiffany's, with comfortable seating and table service offered by the nearby bar.

Royal Court is located on Prom Deck. It is situated adjacent to the Future Cruise Sales and Loyalty desks, as well as Explorers, and looks outward towards Knightsbridge. Here you will find comfortable leather chairs, which can be used when shopping fatigue sets in or if you are required to fill in any paperwork to book your shore excursion.

Queen's Court is found on E Deck. This area is largely unused during port days, but while the ship is at sea it becomes an extension of Emporium and Knightsbridge. Black-draped tables are placed here and showcase the latest designer jewellery, souvenir items and selected clothing.

The lowest located court aboard *Oriana* is **Garden Court**. An extension of the ship's reception area, this area is so named due to the plants that surround the foot of the Atrium staircase. The Garden Court offers space for guests to wait when attending the Reception Desk, while proving an excellent vantage point to look up the full height of the Atrium to the Tiffany glass ceiling above.

Above and centre left: The Queen's Court offers seating near the shops on E Deck.

Below left: The Garden Court is decorated with plants and sculptures.

LAUNDRETTES ◎

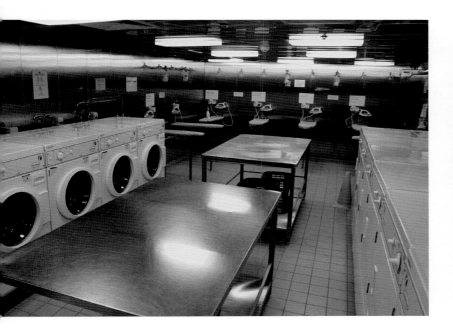
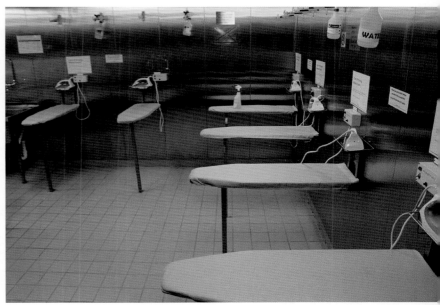

If you're taking a short voyage aboard *Oriana*, you may be lucky enough to have sufficient clean clothing to last the entire voyage. But, given the ship's varied itinerary, chances are you'll need to pay at least one visit to the laundrette.

Fortunately for *Oriana*'s passengers, her original profile as P&O's British-based global cruise ship means she was designed with long-duration cruising in mind.

To that end, the ship has several spacious laundrettes containing washing machines, tumble dryers and ironing boards. They are well-lit and ventilated to offer the most pleasant environment in which to undertake those chores you'd much rather have left at home.

GETTING AROUND

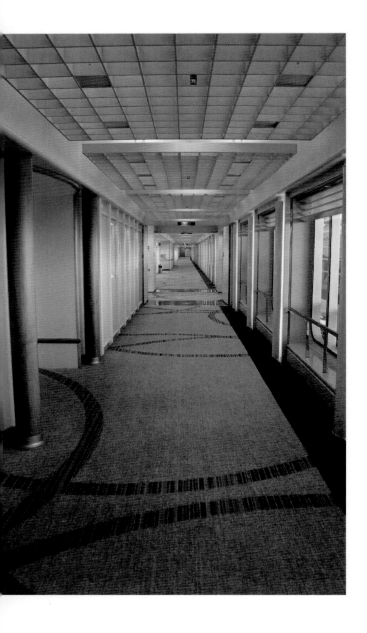

While *Oriana* is not the largest ship in the world, at 69,840 gross tons, 260m long and with ten passenger decks, she is by no means small. Her design was customised to ensure that the 1,880 passengers and 760 crew could move about the ship with ease and simplicity.

A logical design, the ship's layout introduced significant improvements over *Canberra*, which she ultimately replaced. This is largely thanks to *Oriana* being created for one-class cruising, as well as advances in prefabrication used during her build, which allowed her interiors to take on a uniform and intuitive layout.

Oriana contains three main stairways – forward, amidships and aft. A bank of lifts complements each stairway, with four lifts forward, and three each amidships and aft.

These main stairways connect every deck they pass through, with the forward stairway linking all ten decks, from Sun Deck at the top to G Deck at the bottom of the ship. Additionally, *Oriana*'s four-deck-high Atrium connects the retail and reception spaces from D Deck through to F Deck, though here it is stairs only.

Each stairway connects kilometres of corridors and access ways that make up the ship's interior. The corridors have been refreshed often throughout *Oriana*'s career, and as such are elegant and welcoming in feel.

Art adorns the walls, ranging from abstract pieces to whimsical collections of wave impressions and numbers. Each of the main stairways is set upon a backdrop of granite and mirrors, adding to the overall ambiance of the ship, while the carpeting throughout the ship was updated in 2016, lifting *Oriana*'s appearance and making her seem much newer than her twenty-four years.

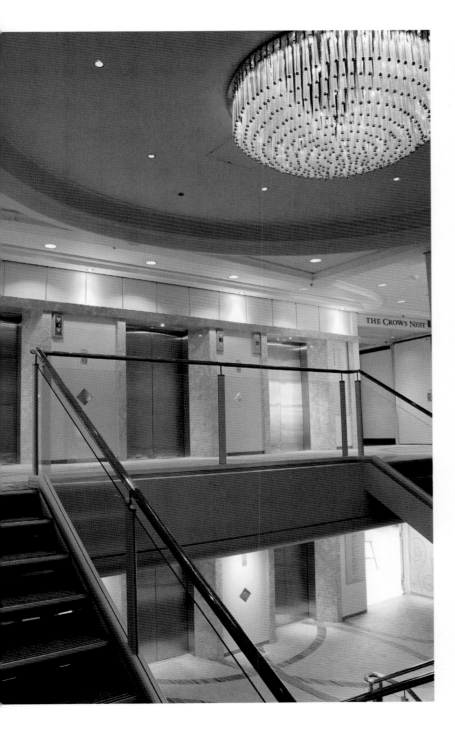

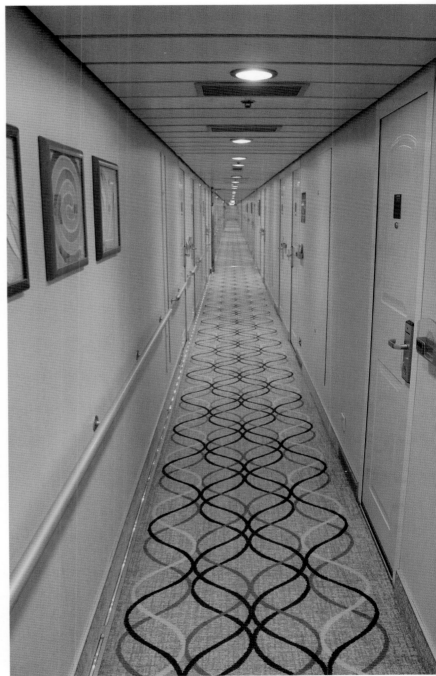

ON DECK

With so much going on inside the ship, it is little wonder that there are also many entertainment options in the outdoor areas of the ship.

Whether you favour relaxing near the pool on a deck chair, mastering one of the traditional shipboard games, or dancing with a drink in hand as the ship sails away from port, *Oriana* has you covered.

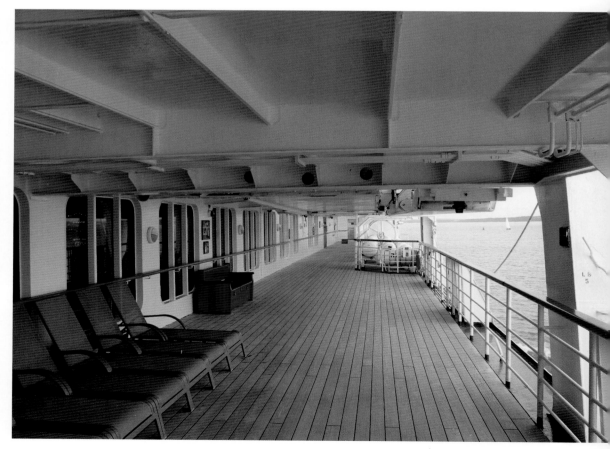

ON DECK AREAS PROFILE

NAME	LOCATION
Sun Deck	Sun Deck
Sports Court	Sun Deck
Sun Terrace	Lido Deck
Riviera Pool & Spas	Lido Deck
Crystal Pool	Lido Deck
Terrace Pool & Spa	D Deck
Promenade Deck	Prom Deck

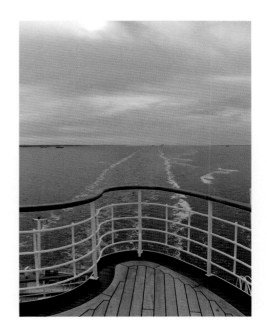

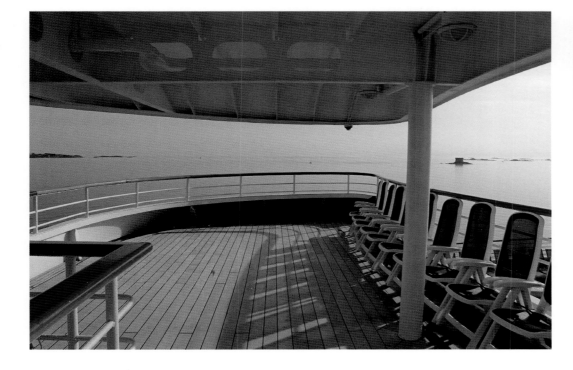

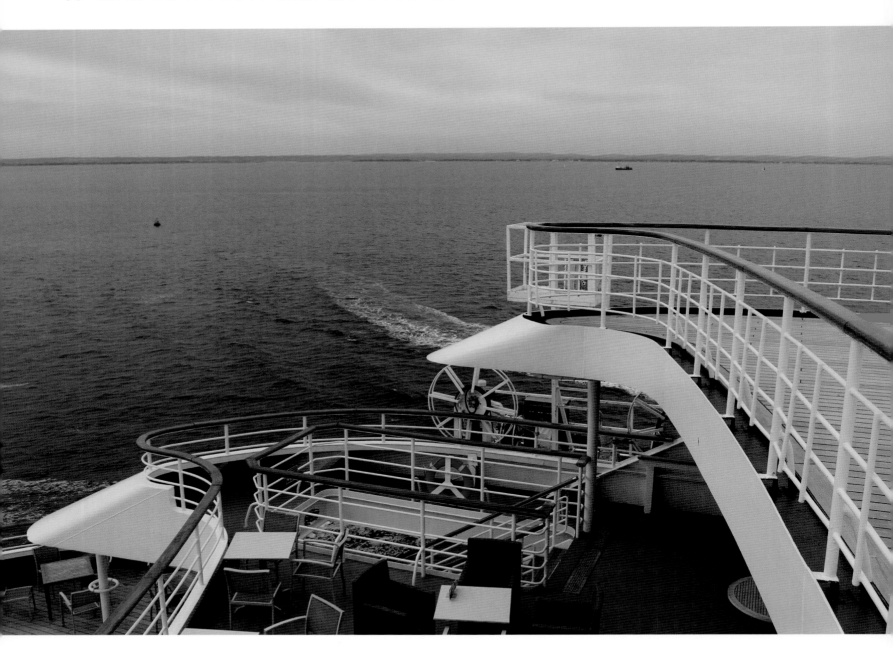

SUN DECK ❧

As it was designed as a replacement for the much-loved *Canberra*, *Oriana*'s architects paid particular attention to ensuring the ship carried forward many of *Canberra*'s most popular features.

One of the most talked about of these is the ship's large, open deck spaces, many of which you will find on Sun Deck. High atop the ship, Sun Deck is largely covered in real teakwood.

A notable exception is an outer walkway on both port and starboard sides, which has a faux lawn finish. This area offers unobstructed views, as it is positioned outside of the ship's glass awnings and is protected by a traditional railing.

At the aft of Sun Deck, you'll find the topmost deck of the ship's distinctive terraced stern. From here, passers-by can enjoy a great view of the ship's large blue funnel, while on the deck the traditional shipboard games of shuffleboard and deck quoits can be found.

Further forward, the deck offers access to both the Crystal and Riviera Pools situated one deck below, with the Sun Deck a popular vantage point to view the sail away parties.

Did you know:

Oriana's terraced stern profile was so well received that it was incorporated into the design of *Aurora*.

SPORTS COURT ❧

Football and cricket might not be games that first come to mind when thinking of sports to be played on a ship, but aboard *Oriana* there are facilities to allow it.

Found amidships on Sun Deck, the football and cricket nets are supplemented by golf nets on the starboard side of the ship. Equipment is provided free of charge to allow passengers to practise and enhance their skills or learn new ones!

Cruise staff are on hand to facilitate tournaments and classes so that, no matter your skill, you will likely learn something new during your voyage.

Did you know:

In the time before jet airliners, international sporting teams would travel abroad on ocean liners. P&O ships commonly transported sporting teams between the United Kingdom and Australia, including the Test cricket team, who would practise aboard the liner so as not to be at a disadvantage when arriving at their destination.

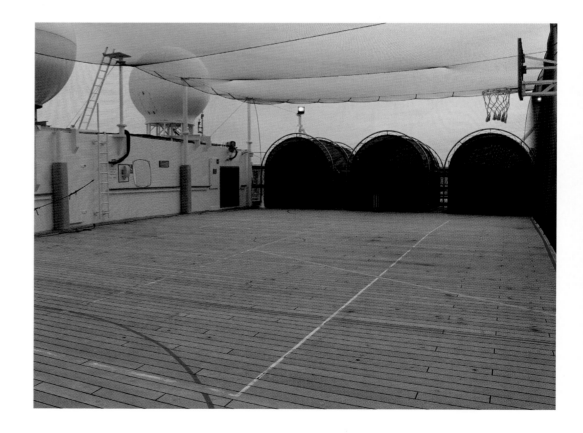

SUN TERRACE ⌒

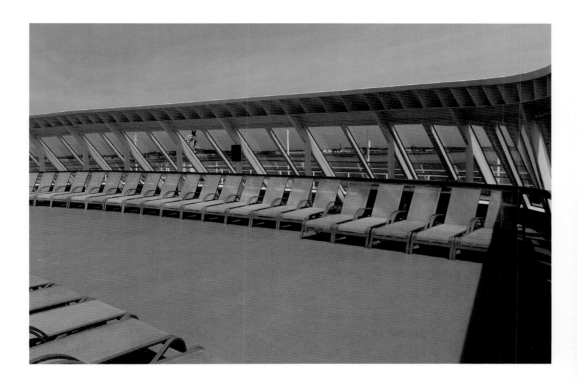

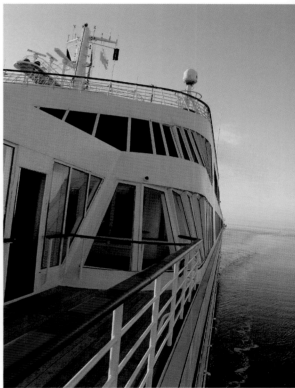

Set at the forward end of Lido Deck, the Sun Terrace offers a quiet open-air environment for travellers wishing to relax outdoors away from the buzz of the rest of the ship.

Split into two areas, the Sun Terrace has deck chairs arranged on a synthetic deck surface and surrounded by glass windbreaks to create a sheltered environment.

From here, wooden doors on both the port and starboard side lead out to a teakwood viewing area that offers views over the bow of the ship. An open-air location with no obstructions, this place is a popular vantage point when the ship visits interesting or unique ports around the world.

RIVIERA POOL AND SPAS ᕫ

Set on Lido Deck, the Rivera Pool and Spas are sheltered by glass screens on both Sun and Lido Deck. A split-level aquatic zone, the pool is surrounded by a decorative wooden surround, which doubles as a bench.

A central stage sits aft of the pool between the two spas. The 'Great British Sail Away' takes place here, with *Oriana*'s cruise staff taking to the stage and leading crowds in singing and dancing as the ship departs port. A built-in sound and lights system add to the party atmosphere.

Surrounded by ample deck chairs, the area is serviced by the adjoining Riviera Bar, while food and snacks can be accessed from the nearby Al Fresco.

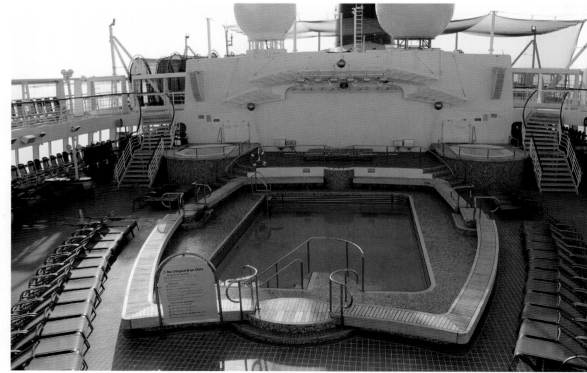

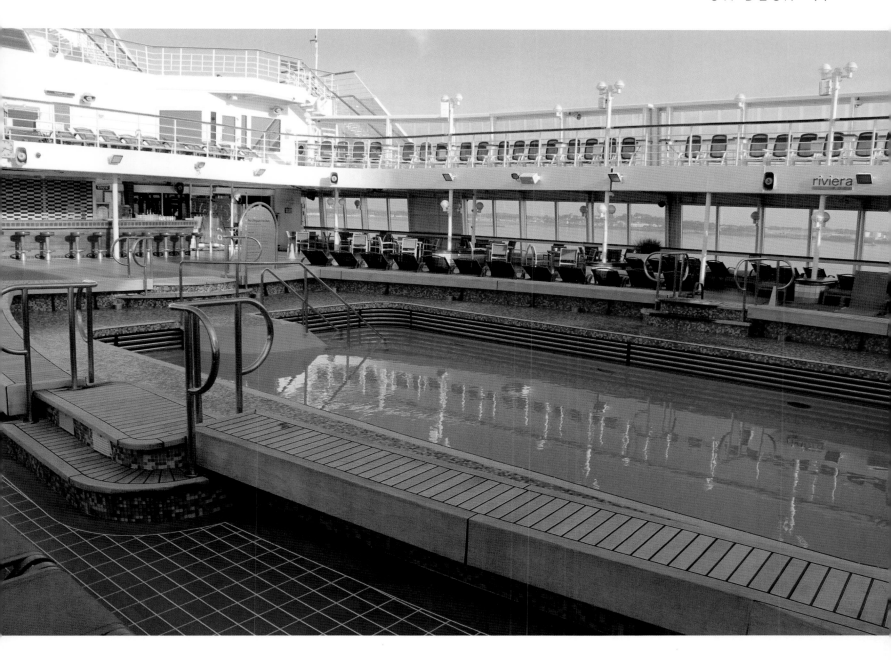

CRYSTAL POOL

If you're looking for less of a party atmosphere, the Crystal Pool offers a quieter location for swimmers.

Larger than the Riviera Pool, the Crystal Pool stands alone with no spas or stages. The pool is surrounded by small gardens and there is a central bronze sculpture by André Wallace entitled *Floating*. It is a popular lap pool as well as a place for quiet relaxation, whether in the water or on the surrounding deck chairs.

Although there is no bar serving this area, passengers can bring food and drinks out from The Conservatory, which is situated immediately aft of the Crystal Pool.

TERRACE POOL AND SPA ⟳

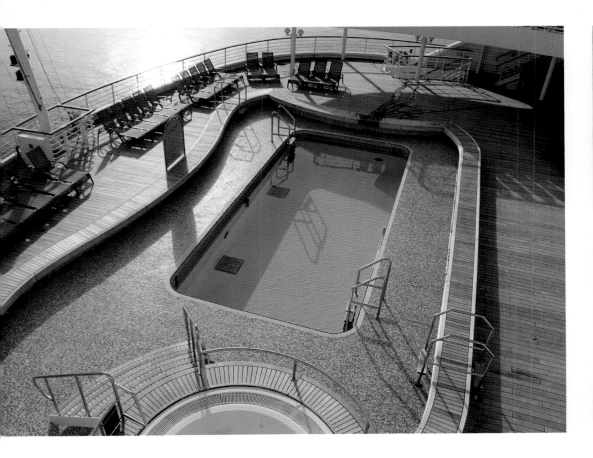

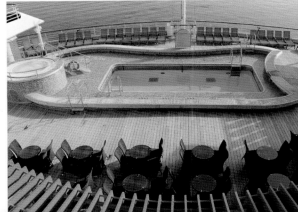

Found at the very aft of D Deck, at the lowest point of the terraced aft decks, is the Terrace Pool and Spa.

Set widthways across the deck, the pool is complemented by a raised spa on the starboard side of the ship, which offers an excellent view over *Oriana*'s stern.

There are limited deck chairs at the aft end of the pool deck, which are supplemented by additional seating on the port side, as well as tables and chairs provided at the nearby Sunset Bar.

PROMENADE DECK ❧

Oriana has a traditional promenade deck that allows passengers to walk a full circuit of the ship. Each circuit is 485m (530 yards) meaning you can clock up a kilometre in just over two laps of the deck.

Because the Promenade Deck is situated above passenger cabins, jogging is not permitted here; instead, joggers are requested to use Sun Deck.

The Promenade Deck is made of teak wood and the ship's fourteen lifeboats and two rescue craft are suspended above the deck, giving the area a traditional feel. Deck chairs are available for those wishing to watch the sea go by in shaded comfort, or there are wooden benches decorated in *Oriana* branding (which also offer hidden storage for the crew).

Watch your head:

Tall people might need to duck on Promenade Deck due to the low-hanging lifeboats and associated equipment.

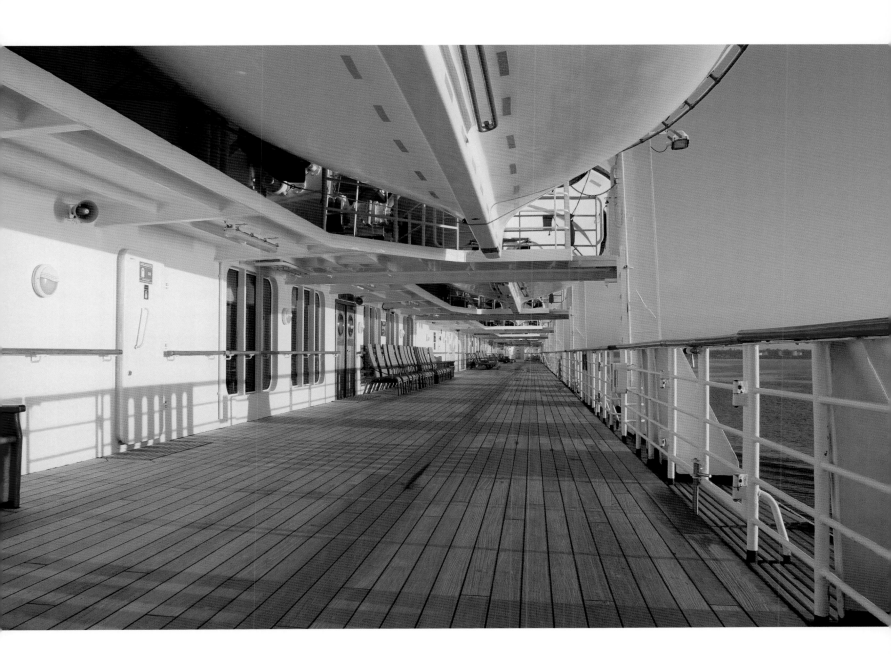

ADULTS ONLY ෧

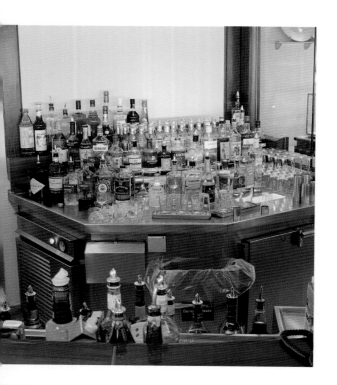

When *Oriana* entered service in 1995, she was heralded as a popular cruise destination for all ages. However, following the success of P&O's adults-only ships, *Oriana* was converted to an adults-only vessel in 2011.

Catering for passengers 18 years of age or above, the conversion involved removing her child-friendly areas and replacing them with facilities more suited to her new adult demographic.

The main changes aboard related to the aft of D Deck where, prior to *Oriana*'s conversion, the kids' playrooms, on-deck play area and paddling pool were located. These facilities, being no longer required, were removed and instead replaced with additional accommodation and on-deck relaxation space.

Twelve new balcony cabins, four new obstructed-view outside cabins and eleven new inside cabins were added in the spaces previously dedicated to *Oriana*'s children's activity rooms. The paddling pool and on-deck play area were both converted to open deck space, and more deck chairs were added to these locations.

With *Oriana*'s departure from P&O Cruises in 2019, her sister ship *Aurora* has undergone a similar refit to take *Oriana*'s place as a mid-sized adults-only ship.

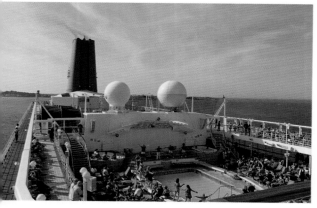

Above left: Drinks on offer at *Oriana*'s bars.

Below left: The Great British Sail Away Party.

Opposite page:

Above: Oriana's wake as she departs Southampton.

Below: Oriana as seen from Saint Peter Port.

CRUISING THE WORLD ⟳

Following *Canberra*'s conversion into a full-time cruise ship in 1974, she undertook regular world cruises. The ship's ocean-liner design meant that *Canberra* could handle deep-water sea routes and the unpredictable seas that can otherwise hinder a smooth cruise voyage.

P&O were keen to ensure their new flagship would also offer a comfortable world cruise experience. Her long bow, fast speed and good sea-keeping characteristics meant *Oriana* suited this role, with her first world voyage taking place in 1996.

While the ship's itineraries have focused on shorter duration voyages in recent years, she nonetheless still undertook occasional longer duration voyages. Past cruises have taken her to destinations as far afield as Sydney, Hong Kong and Cape Town.

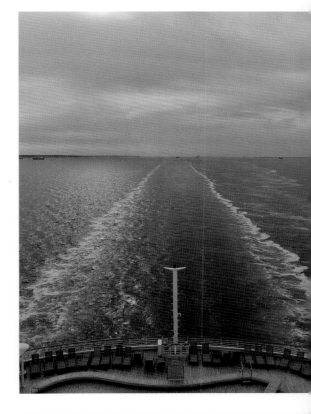

Red Alert! Commodore Gibb recalls the ship's maiden arrival to Funchal, 12 April 1995:

Glorious sunny, calm day, approaching Funchal, our first port of call, with veteran BBC reporter Judith Chalmers on the navigating Bridge. Suddenly, without warning, the jangling of the emergency fire bell and an indicator on the Bridge console that a fire was indicated in passenger accommodation. Fire doors closing automatically. No. 1 fire party dispatched.

Moments later, another indication of a second, and then a third and fourth showing 'red' alert. Fire doors automatically 'closing up' the entire passenger accommodation. No. 2 fire party dispatched then emergency No. 3 party. Running out of fire parties ...

Reports coming in indicate 'No fires found', but that breakfast toast was being prepared throughout the passenger galleys in all areas!

Although the detectors had been tested during sea trials, the 'sensitivities' had been set too low. Panic over!

BBC reporter assured that bells and alarms were not usual routine. Calm restored.

Safely berthed alongside, passengers had reassuring toast for breakfast.

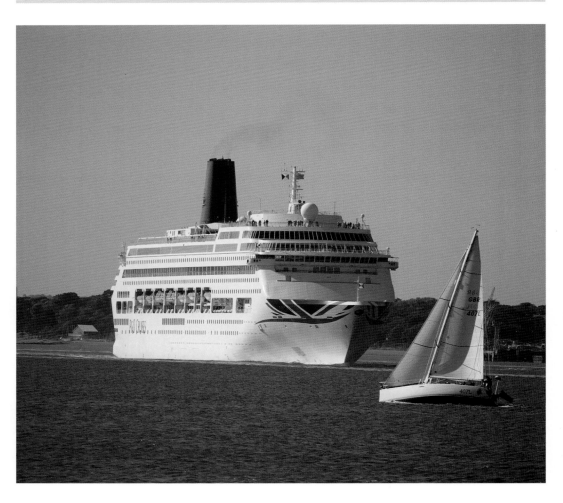

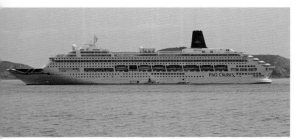

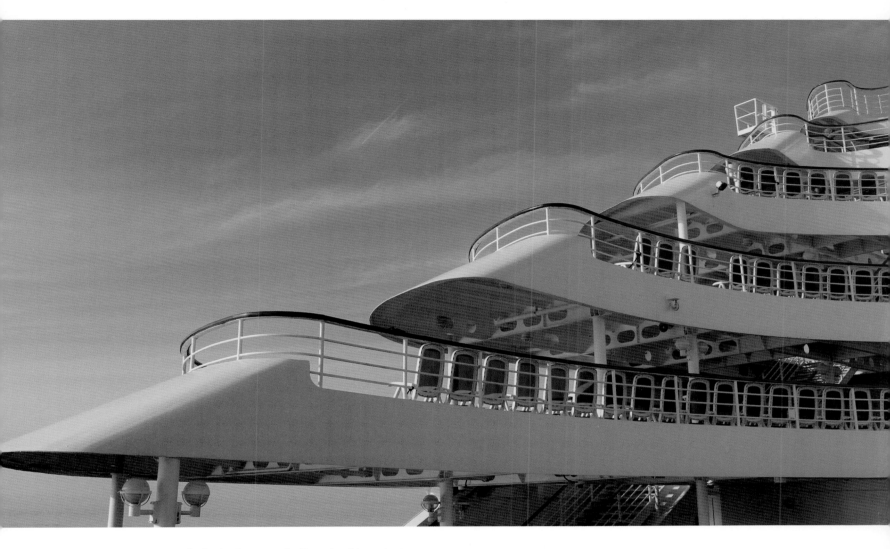

Above: Oriana's terraced aft decks are a hallmark of her design.

Opposite page:

Top left: Oriana's Tender Boats at the pontoon.

Centre and below left: Oriana at Anchor off Guernsey.

Right: Oriana departing Southampton in June 2018.

THE PROFILE

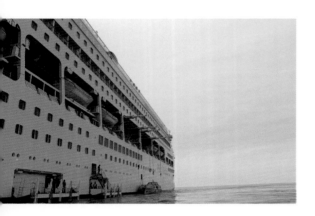

For a cruise ship built in 1995, *Oriana* has a surprisingly traditional appearance. She has a longer, narrower bow than most cruise ships, which allows her to comfortably undertake regular crossings of the Bay of Biscay and world voyages as well as occasional Atlantic transits.

Oriana was built to resemble P&O's graceful *Canberra*, and as a result they share a number of traits. *Oriana*'s aft decks are terraced, which give her a pleasing profile and make the ship stand out among modern cruise ships, and her lifeboats are carried inboard with slanted support struts; these are both traits she adopted from *Canberra*.

During 2011, a ducktail was added to her stern. This somewhat interferes with her graceful lines but helps reduce the stern vibrations that cause problems when *Oriana* travels at speed.

For much of *Oriana*'s career she wore the traditional P&O livery of a buff funnel with a white superstructure and hull. However, in early 2015 the ship was repainted in a new livery, which included the addition of stylised hull art on her bow.

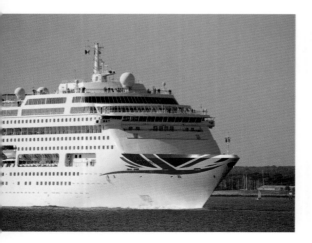

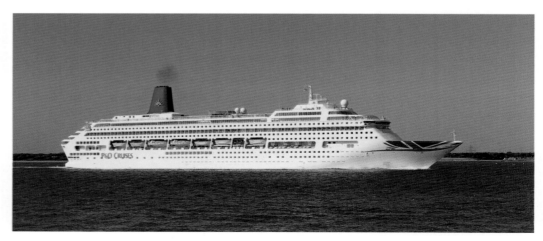

THE MAST ⟲

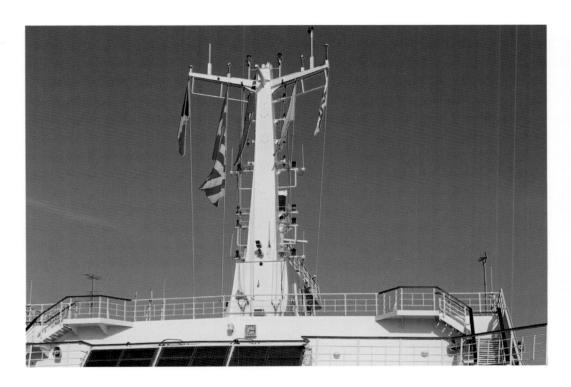

The second tallest point of the ship after the funnel, *Oriana*'s mast sits atop Sun Deck. A crew-only area, the mast is accessed via wooden-railed stairways from the deck below, allowing crew to change flags and ensure the structure is maintained.

The base of the mast is its widest point, with the lower portion of the structure protruding forwards. This area houses a railed walkway where three SAM navigational radars are housed to provide navigational services to the Bridge.

The most noticeable part of the mast is the thinner, taller structure, which sits on the aft end of the base. Here, navigational lighting is affixed, while at the top, twin yardarms provide space for the various flags flown by *Oriana* throughout her voyages.

THE FUNNEL ⌒⌒

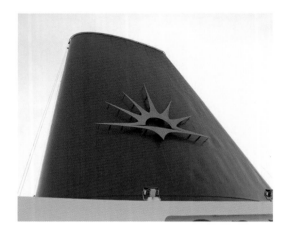

The tallest point on *Oriana*, the funnel sits two thirds aft atop *Oriana*'s Sun Deck. Originally painted in a buff colour scheme, since 2015 the funnel has sported a dark blue livery with a stylised rising sun motif attached to both port and starboard sides.

Canberra's twin funnels inspired the design of *Oriana*'s funnel, which accounts for its shape. Its primary function is to ventilate the ship's eight MAN B&W diesel engines, although it also holds navigational lighting.

When compared to newer members of the P&O fleet *Oriana*'s funnel is much taller. This is because the ship's superstructure is not as tall as many of her successors', so even with a tall funnel she can still pass under bridges.

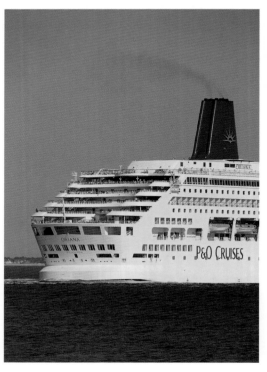

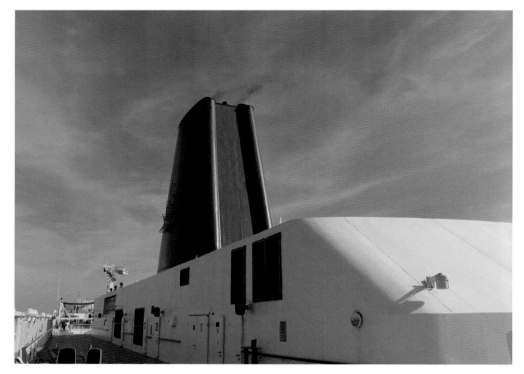

CREW ONLY ɠɠ

As the passengers aboard *Oriana* enjoy the ship's amenities and entertainment, behind the scenes a team of hundreds work around the clock to ensure the ship operates smoothly.

Under the command of the Captain, the crew aboard *Oriana* number 760 people. They operate a variety of roles, from housekeeping to engineering, and over the decades have ensured that *Oriana* has maintained her position as one of Britain's most-loved cruise ships.

The crew-only areas are a flurry of activity, with large portions of the ship unseen to passengers. The areas are designed to enable the most efficient running of the ship, while still ensuring that those working aboard *Oriana* have comfortable and pleasant amenities (even if they are not as luxurious as the public areas). These amenities include a crew mess, where meals are served for those working aboard; accommodation areas; and recreational zones, including a shop, bars and a swimming pool located on *Oriana*'s bow.

Deep within the vessel, the engine room provides energy to not only drive the ship but also power the hotel services. Everything from light bulbs to music, air conditioning to the ship's whistle is powered from these engines, which comprise eight MAN B&W units.

While most modern cruise ships have diesel electric engines, *Oriana*'s power plant is a direct-drive system. Four of the eight engines are dedicated to propulsion duties, while the other four are committed to hotel services. Her propulsion engines are connected to variable-pitch propellers via Vulkan-ratio couplings and gearboxes.

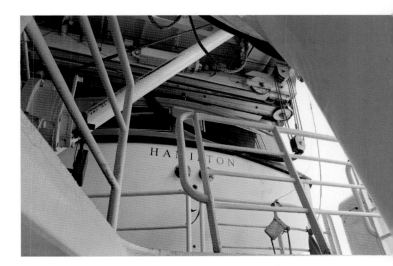

Did you know:

Oriana's engines provide over 37,700kW of power.

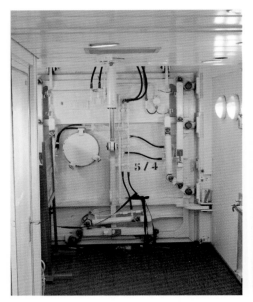

Did you know:

From the start of her career, *Oriana* has suffered from vibrations in her stern due to cavitation. To overcome this, she is often slowed down during mealtimes to reduce vibrations in the Oriental Restaurant. In 2011 a ducktail was added to *Oriana* in an attempt to rectify the cavitation issue, but it was only partially successful.

The ship has twin rudders and bow/stern thrusters, which assist with stability and manoeuvrability. Together with air conditioning, electrical systems, fresh water systems and sewage; the mechanical side of the ship is immense. This entire operation is managed under the watchful eye of the Chief Engineer, who oversees a team of engineering specialists.

More noticeable to passengers are the crew of the hotel services operation. Managed by the Hotel General Manager, the team provide a variety of functions including chefs, waiters, bar tenders, DJs, photographers, entertainment staff and room attendants. These people are in daily contact with passengers and are essential to ensuring that each cruise is enjoyable for *Oriana*'s guests.

THE BRIDGE ∾

High atop *Oriana*'s superstructure at the forward end of A Deck is the ship's Bridge. It is here that the Captain, Bridge officers and navigational team control *Oriana*, safely navigating the ship from port to port throughout her career. *Oriana*'s Bridge is different from most modern cruise ships, as it contains a few features that are more commonly associated with vessels of an older vintage.

One such feature is her open Bridge wings. The choice to build the ship with open wings was done after consulting with Commodore Gibb, *Oriana*'s first master. During his years of experience at sea, he had witnessed the benefit of being able to feel the wind; it is particularly useful when performing docking manoeuvres.

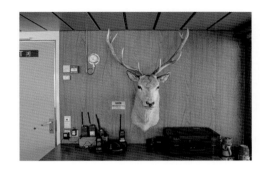

'Sven' is a feature found on the Bridge of many P&O Cruise vessels. (Andrew Sassoli-Walker)

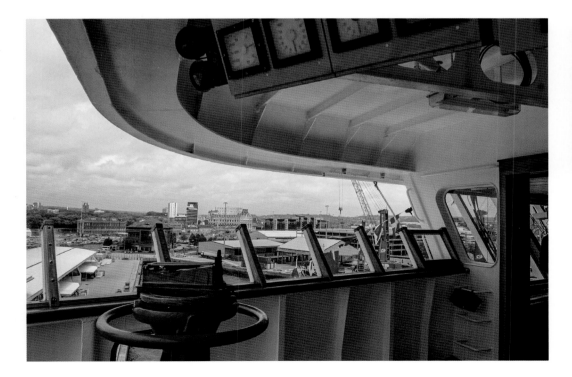

Above: Oriana's bell is found on the ship's Bridge. (Andrew Sassoli-Walker)

Left: The open Bridge wings on *Oriana* were a design suggestion of Commodore Gibb. They aim to help with identifying wind speed and direction during docking manoeuvres. (Andrew Sassoli-Walker)

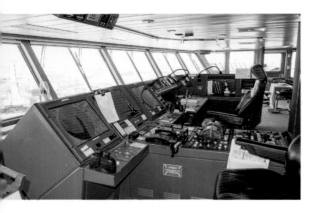

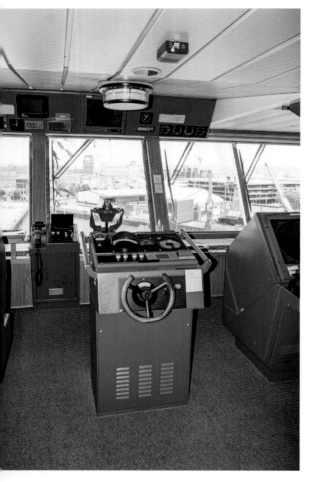

Since *Oriana* entered service, awnings have been installed over the top of the Bridge wings to offer shelter from the sun and rain, but the sides remain open, so *Oriana*'s Bridge wing consoles are stored in waterproof cases to protect them from the elements.

Additionally, while *Oriana*'s navigational equipment is modern, she sports a traditional wooden wheel – another suggestion of Commodore Gibb – that can be used to steer the ship. In addition to the more commonly used LIPS joystick, this wheel gives *Oriana*'s systems a redundancy factor, which is useful in case of emergencies or mechanical failures.

The majority of *Oriana*'s Bridge consoles are blue, a trait she shares with many modern vessels. Black leather seating is provided for the officers of the watch, while the entire Bridge front offers an unparalleled view over the bow of the ship, as well as astern via the two Bridge wings. The Bridge not only contains the navigational equipment, such as electronic charts, telegraphs and emergency services, but also stores the hundreds of flags the ship carries to fly at each of the varied ports she visits.

Did you know:

A feature of *Oriana*'s Bridge is 'Sven'. A mounted stag head, Sven was gifted to the ship on its first call in Olden by Aslak Lefdal. Other Svens can be found on the Bridges of many other P&O Cruises ships.

Above left: The modern Bridge design of *Oriana*, with computer consoles in a logical arrangement. The design was so successful that it was replicated aboard many other cruise ships. (Andrew Sassoli-Walker)

Left: Oriana's wheel is a traditional design. Made of wood, it offers a good level of redundancy for the officers and Bridge crew, who otherwise rely on the LIPS joystick to manoeuvre the ship. (Andrew Sassoli-Walker)

TECHNICAL INFORMATION ෴

Tonnage:	69,840 tons
Length:	260m
Width:	32.2m
Draft:	8.3m
Passenger Decks:	10
Passengers:	1880
Crew:	760
Main Engines:	4 x MAN B&W L58/64 diesel engines and 4 x MAN B&W 6L40/54 auxiliary units
Speed:	24-knot service speed, 26-knot maximum speed
Call Sign:	ZCDU9
Propellers:	2 x four-bladed controllable-pitch propellers
Rudders:	2 x rudders, one aft of each propeller
Bow Thrusters:	3 LIPS manufactured
Stern Thrusters:	1 LIPS manufactured
Stabilisers:	2 x Brown Brothers

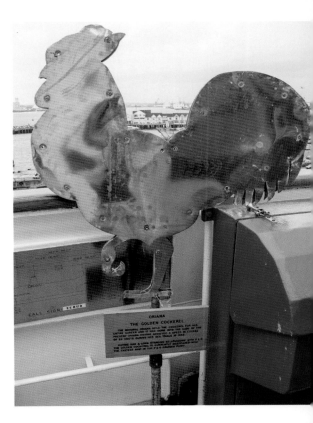

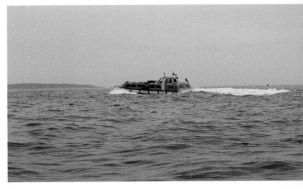

Above right: The Golden Cockerel has been held aboard *Oriana* since *Canberra* retired. It signifies her position as the fastest ship in the fleet. (Andrew Sassoli-Walker)

Right: One of *Oriana*'s tenders making a fast passage between the ship and the port at Guernsey.

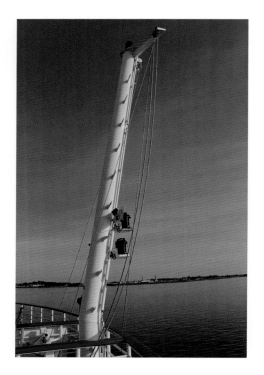

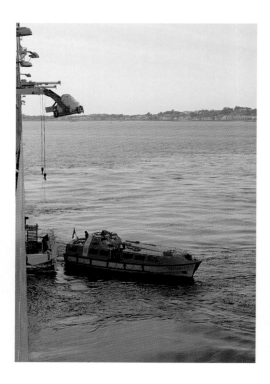

Above left: The stern flagstaff is used to fly the Red Ensign aboard *Oriana.*

Above centre: One of *Oriana*'s powerful spotlights mounted above the Bridge.

Above right: Tendering creates a hive of activity. Here, one of *Oriana*'s tenders is pulling away from her pontoon to make another passage to shore.

Left: Two of *Oriana*'s loudspeakers, which form part of the ship's public address system. They can be used to communicate to every part of the vessel.

INTERESTING FACTS ෨

On an average fourteen-night cruise, *Oriana*'s passengers and crew will eat over 116,500 main meals. To make these meals, the ship will use:

- 14,600kg (32,187lb) of meat
- 1,700kg (3,747lb) of shellfish
- 3,700kg (8,157lb) of fish
- 3,500kg (7,716lb) of bacon, ham and gammon
- 8,000kg (17,636lb) of fresh fruit and vegetables
- 8,500kg (18,739lb) flour
- 18,000kg (39,683lb) potatoes
- 650kg (1,433lb) coffee
- 1,900kg (4,188lb) sugar
- 51,000 fresh eggs
- 10,500 litres (2,773 gallons) milk and cream

On a fourteen-night cruise on board *Oriana*, 4,000 litres of ice cream will be consumed – that's enough to fill fifty average-sized bath tubs.

At 32m wide, *Oriana* could cruise down The Mall in London with 3m to spare.

Oriana uses 1,326,000 eggs each year!

A MASTER'S PERSPECTIVE 🌀

REFLECTIONS ON ORIANA BY COMMODORE IAN GIBB

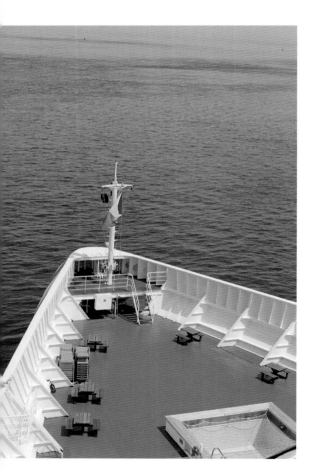

The view over *Oriana*'s bow was a familiar sight for Commodore Gibb during his time aboard the ship.

In 1993 I was asked by P&O's Chairman Sir Jeffrey, now the Lord Sterling of Plaistow, whether I would take command of the new *Oriana*, then under construction in Papenburg, Lower Saxony. My initial reaction was that, being only a couple or so years from retirement, the post should go to a younger man. However, having been 'persuaded', I looked upon the appointment as a great honour and would endeavour to fulfil the role as her first Master to the best of my ability.

Here was a ship that was to be successor to the iconic *Canberra*, of which I had been in command for a number of years. I was being tasked with the responsibility of ensuring that, as far as possible, the ambiance of that marvellous old warhorse be melded into her state-of-the-art successor.

The first task was to select a group of senior on-board personnel who would act as the task force in Germany in the run-up to her entry into service. Vitally, we got a team of superb quality who, together with the management of Jos. Meyer, ensured that when the ship entered the North Sea on trials in the spring of 1995, she was prepared as much as possible for her pioneering role as the 'face of the modern cruise liner', and a worthy successor to *Canberra*, the elderly lady of the seas.

The months up until her slow progress down the River Ems were truly busy and involved many long hours and days during the northern winter, to ensure that all was as ready as could be for her working life.

Visits were made to navigational instrument makers, engine manufacturers, galley equipment makers, carpet manufacturers and showrooms, and it was pleasing to note that many of the ancillary workers on board at the yard were indeed British, from the carpet-layers to the carpenters.

Much thought had gone into the design of the vessel, and it was more than a happy coincidence that the 'double funnel' and slanted supports for the lifeboats and passenger tenders on the Promenade Deck had been features of her predecessor.

However, it was the Bridge design that was uppermost in my mind and, together with the Navigating Officers, I came up with a layout that set the pattern for many vessels in the next few years – uncluttered and serviceable. Joystick control of the main engines, bow and stern thrusters, and twin rudders had to be learnt, and the senior Southampton pilot and I had many sessions on the simulator to 'get a grip' on the 'LIPS stick' – not entirely satisfactorily at first, as we frequently berthed *Oriana* in the nearby car park instead of No. 106 berth at Southampton Docks until the simulator was 'tweaked'. Happily, this tweak happened before *Oriana* entered service, so the car park was spared our arrivals!

Did you know?

Oriana cost £280 million to build.

The sword that was presented to Commodore Gibb in the presence of HM Queen Elizabeth II during *Oriana*'s naming ceremony. It takes pride of place near the ship's reception desk.

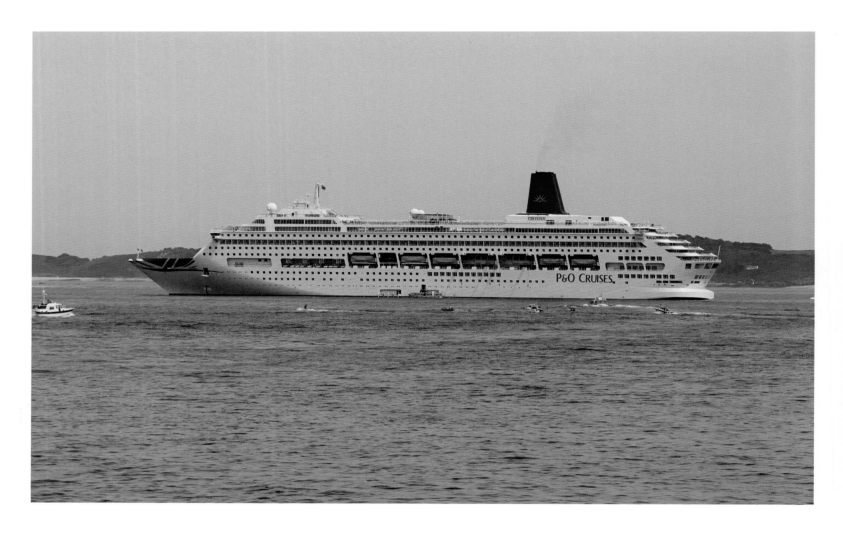

Oriana in 2018, towards the end of her successful P&O career. She is dressed in the P&O Cruises updated livery.

Did you know?

Oriana's keel was laid on 11 March 1993.

Trials in the North Sea during the late-winter gales could not be called an entire success. At speeds in excess of 25 knots problems arose with cavitation from the state-of-the-art scimitar-shaped variable-pitch propellers, necessitating a visit to the Blohm & Voss drydock in Hamburg mid-trial to partially rectify the LIPS propeller problem. Many overnight sessions at speed under trying conditions were necessary. This meant that we were heartily pleased to leave the North Sea and arrive in Southampton for the Naming Ceremony by HM the Queen on 6 April 1995.

We certainly had a ship of which to be proud, and it was now the job of the splendid ship's company to justify the faith that had been placed upon us.

We got off to a grand start with our first port of call, Funchal in Madeira at noon on 12 April – a favourite port of us all, and one that gave us the warmest of welcomes.

Our initial cruise to the Canary Islands and Portugal was a resounding success, and ambassadorial visits were interspersed with those of travel agents and port authorities wherever we went. This set the pattern for the next few cruises and it was a heady, albeit tiring, few months until I proceeded on leave in early June – not to return until mid August, after a well-deserved leave.

Naturally there were a few problems, many small in nature, and eventually the cavitation problem was resolved, although this was not without heartache.

The main joy was that *Oriana* was truly accepted by the passengers, who fell for her in their droves. It was a real pleasure to me that the ship's company were so proud of our ship, and this feeling was transmitted to our guests.

Over the next fourteen months, before I retired, I gained huge satisfaction and pleasure from the fact that I had been there 'at the start' and had watched the ship being constructed in individual 500-tonne prefabricated units to emerge chrysalis-like into its final beautiful shape. She was a far cry from the behemoths of the twenty-first-century passenger liners that were to come.

Proudly we circled the oceans of the earth, culminating in a tremendous welcome on the round-the-world voyage in Sydney on 18 February 1996, where we were treated to a firework display of extraordinary magnificence.

Wherever we went, we were greeted in majestic fashion – a true and fitting result of years of dedicated performance from the P&O Board for their vision, and the ship's company for living up to the responsibility that had been placed upon their shoulders.

They had not let us down.

Ian Gibb

Did you know?

Oriana was floated out on 30 June 1994.

Oriana holds the Golden Cockerel trophy for being the fastest ship in the fleet. The previous holder was the *Canberra*, and before her the first *Oriana*.

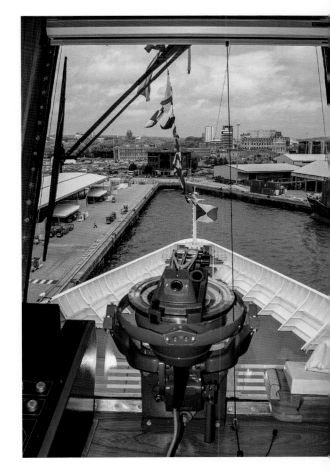

A view of *Oriana*'s bow, as seen from inside the Bridge at rest during a port day. (Andrew Sassoli-Walker)

BIBLIOGRAPHY

BOOKS

Poole, S., and Sassoli-Walker, A. (2012). *Oriana & Aurora: Taking UK Cruising into a New Millenium.* Amberley Publishing.

Henderson, R., Cremer, D., Cross, R., and Frame, C. (2018). *A Photographic History of the Orient Line.* The History Press.

Henderson, R., Cremer, D., Cross, R., and Frame, C. (2015). *A Photographic History of P&O Cruises.* The History Press.

PERSONAL CONVERSATIONS

Commodore Ian Gibb – *Oriana*'s first Master.

Andrew Sassoli-Walker – P&O Cruises expert and author.

Patricia Dempsey – Shipping writer and enthusiast.

Jenny Hadley – P&O Cruises Public Relations.

WEBSITES

Oriana of 1995 - www.orianaof1995.blogspot.com

P&O Cruises – www.pocruises.co.uk

Ship Technology 'Oriana' – www.ship-technology.com/projects/po-oriana-cruse-ship/

OTHER DOCUMENTS

Horizon, *Oriana*'s daily program – Cruise X810.

Oriana fun facts as supplied by P&O Cruises.

RECOMMENDED READING

If you enjoyed this book, we recommend you check out these other titles by Chris Frame and Rachelle Cross:

Looking for more maritime history and cruise ships?

You can follow Chris and Rachelle on social media by searching for the handle @chriscunard on Facebook, Twitter, YouTube and Instagram, or you can visit them online at www.chrisframe.com.au and www.chriscunard.com

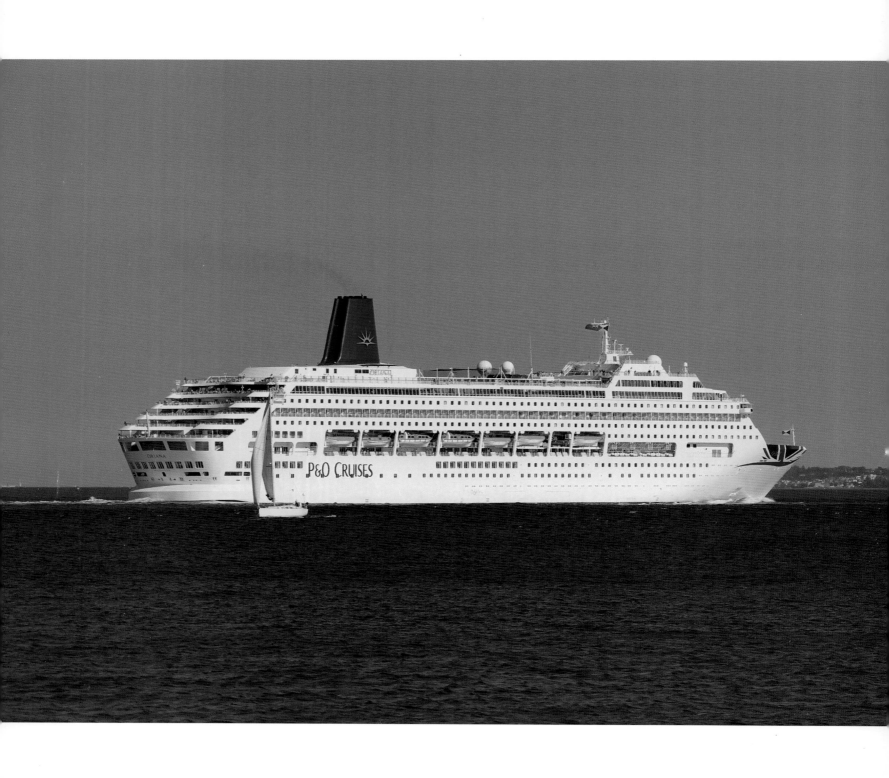